IMAGES
of America

GREATER
FRENCH VALLEY

Mary Rice Mulholland
"Mimi"

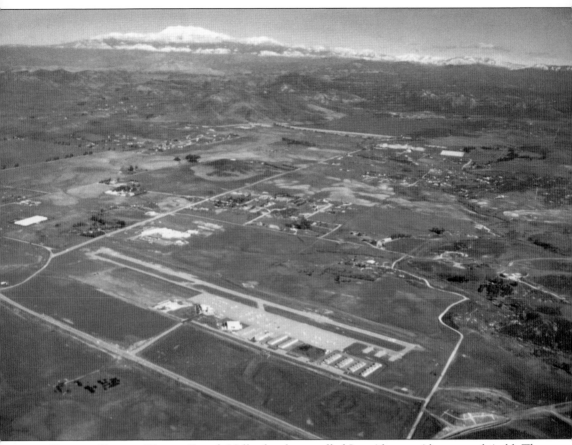

GREATER FRENCH VALLEY. French Valley has been called Los Alamos, Alamos, and Auld. The name first appeared on maps around 1913 and may have been taken from George W. French, the first "police judge" in the county. The area north of Temecula may have also been called French Valley because of the great number of French immigrants. The body of water is Lake Skinner, which covers most of Auld Valley. (Ray Borel.)

ON THE COVER: In 1897, Fred Cooper fell in love with Clara Robertson, Hyatt School's first teacher. He proposed and she accepted, so he built this two-story house just for her before they married. The picture's photographer, Thomas Milholland, bought the house around 1905, and it remained in his family for many years. It burned down in the 1970s. (Joan Cooper Roripaugh.)

IMAGES
of America

GREATER
FRENCH VALLEY

William J. McBurney and
Mary Rice Milholland

ARCADIA
PUBLISHING

Published by Arcadia Publishing
Charleston SC, Chicago IL, Portsmouth NH, San Francisco CA

Printed in the United States of America

Library of Congress Control Number: 2009920014

For all general information contact Arcadia Publishing at:
Telephone 843-853-2070
Fax 843-853-0044
E-mail sales@arcadiapublishing.com
For customer service and orders:
Toll-Free 1-888-313-2665

Visit us on the Internet at www.arcadiapublishing.com

William James McBurney
1928–2009

*This book is dedicated to William J. McBurney, who was devoted
to preserving the history of the Greater French Valley. He recorded
what he knew and prodded others to do the same. Under his capable
direction, the history reached the publisher. Sadly, he was called
to his final rest before he could touch the published volume.*

*The early settlers of the area planted acorns knowing full well that
the shade from the mighty oaks would be enjoyed not by them but
by future generations. We are eternally grateful to the generosity
of William J. McBurney for the acorn he planted to be enjoyed
not by him but by his family, friends, and generations to come.*

CONTENTS

Acknowledgments

We are indebted to scores of people without whose encouragement and contributions of time, photographs, and information this book would not have been possible. The photographs and information in this book came from the private collections of current and former Greater French Valley residents. Unless noted, all photographs presented are from the Mary Rice Milholland family collection.

We especially acknowledge and thank Annie Borel for family pictures and information she gathered and put forth in her privately published "Welcome to French Valley" historical calendar and her father, Alexander A. Borel. She also wrote most of the captions for chapter three.

Special acknowledgement also goes to Gail Wanczuk Barton for providing the photographs and putting together the entire seventh chapter for us—thank you, Gail! Tommy Rawson, her grandfather, would be proud of her.

Lorna Jean Pittam Bien provided the pictures and information making the history of Sage possible, along with Steve Lech; Verna Parks McFarlin; Ellen Sheld Milholland; her daughter, Doris Smith; and the late Johnny Sanchez.

We are forever indebted to the late William Kirk Auld, fondly remembered as Bill, for his pictures and information of the Auld history. We also thank his daughter Marlene Auld Ballestrasse.

For contributing to the rich French Valley history, we thank the late Helen Cummins Rheingans and her groundwork, as well as Carl and Betty Rheingans. Thank you also goes to Denise Pourroy Ziony, Evelyn Blackmore DeCou, Betty Johnston, Jean Bailey, and Penny Smith of the Edmund Nicolas family; Ray and Brenda Borel; the Fredrick Joseph Pourroy family; Borghild Frick Wolter; Conrad Frick; Frank and Loretta Endres; and Dorothy Rail Taylor, Fred Thompson, and the late Rachael Schmoker of the Joseph Vance Thompson family.

Others we wish to acknowledge and thank are Joel and Alan Bashaw, Jessie Joan Cooper Roripaugh, Viola Carlson, Elizabeth Conrad Sheld, Nyle Bloodworth, Linda Brown Leeper, Esther and Don Trunnell, Marge Trunnell Hearell, Marlen and Anne Sheld, and Harold and David Baisley.

Thanks also go to Gregg Cowdery of the Winchester Historical Society of Pleasant Valley; Dr. Lisa Woodward, archivist at the Pechanga Indian Reservation; Lynda Goldberg; Rebecca Farnbach; and the Heritage Room of the Hemet Public Library.

One may ask why other families and places are not featured in the book. The answer is that we worked with the photographs and stories we had access to.

There are unnamed others who lent us moral support and pointed us toward helpful resources. Let us not forget the forbearance of our spouses, Jerry Milholland and Alice McBurney. We sincerely thank each of you for helping us with this book, which was a labor of love.

INTRODUCTION

Greater French Valley includes French Valley, Auld Valley, Tucalota, Sage, and Rawson Country (Crown Valley) for a total of about 300 square miles. In ancient times, Native Americans inhabited the area in as many as 12 named archeological sites of long-gone villages.

They were an adaptive people and learned to live off the fruits and roots of the plant life and the animals they were able to kill. In this area, there are many sites where the early natives stopped to harvest acorns, yucca, and chia. Their grinding holes are in many boulders in these hills. The aboriginal people managed to live and prosper until the mission fathers built San Luis Rey Mission in 1798 and set out to convert all the natives to Catholicism and to teach them to be loyal subjects to Spain. They were formed into bands that herded the cattle, sheep, and pigs belonging to the mission. The Luiseños, as they were known, occupied the area from Oceanside to Pala to San Jacinto and north to San Bernardino. Our whole valley was used as a grazing area for the huge herds of cattle and sheep required to feed the large population and for export. By 1826, San Luis Rey reached its maximum population of 2,869 native neophytes and had 28,900 sheep and thousands of cattle. They also had a crop of 12,000 bushels of grain. When the Mexican government closed down the missions in 1834, the natives who had been under the paternal mission system were left to fend for themselves. Many worked in almost slave-like conditions to survive on the ranchos that were coming under private ownership as Spanish and Mexican dons quickly claimed the mission lands. After the Mexican-American War in 1848, settlers from the east started migrating to this area, slowly at first but in ever increasing numbers after the gold rush started, and California achieved statehood in 1850. This book is about the settlers who arrived after 1860. Most came after 1882, when the railroad brought them to the area without the long trek by wagon train that was the previous choice.

Many of the settlers were emigrants from France taking advantage of the homestead laws that were in effect at the time. They were faced with the difficulty of learning a new language as well as learning how to make the land support them. At the time they were settling their homesteads, they had to choose where to build their house, which was controlled by the availability of a site for a well that could be dug by pick, shovel, and buckets to remove the dirt. Dug wells were limited to a depth of about 50 feet because of the danger of cave-ins and the difficulty of removing the dirt. After the well was dug, one still needed to get the water to the surface. Until windmills became common in the 1880s, the settlers needed to drop a bucket into the water and pull it up with a rope. Nowadays patches of eucalyptus and pepper trees mark the site of the pioneers' homes. Many were destroyed by fire, but many were abandoned and sold when the recurring droughts broke the farmers. Now acres of homes cover the lands of many of those pioneers, and the remaining farmland is owned or leased by the few large-scale farmers who were wise enough or lucky enough to survive.

By the 1890s, several enterprising souls had bought the necessary equipment to drill wells with horse- or mule-driven rigs. This allowed new settlers to set their homes away from the creek beds,

because now wells could be hundreds of feet deep with an iron casing. Water witches (dowsers), people who claimed supernatural powers to find water, were common, and few wells were dug without consulting one. This was because most of this area was dry, and well drillers often would not find water no matter how deep they dug; superstition was as good an answer as any.

In the 1930s, the Metropolitan Water District (MWD) was formed to bring Colorado River water to Los Angeles with a large aqueduct across the desert and through the San Jacinto Mountains. It was the largest water transport project since Roman times. The tunnel through the San Jacinto Mountains from the south hit a tremendous spring in the middle of the mountain that drained for years, holding up the drilling. The tunnel was completed in 1938, and shortly thereafter, many springs throughout our valley dried up because the column of water inside that mountain was the force feeding the springs and artesian wells. Springs and wells went dry, and agriculture suffered as a result. The wells also ran dry due to droughts in the 1950s and 1960s.

In 1964, MWD bought the Auld Ranch and constructed a 109-foot-high dam across the west end of the valley nearly a mile long. This created Lake Skinner, with a capacity of about 44,000 acre-feet filled with runoff from Tucalota Creek, the Colorado River Aqueduct, and the California water project from Feather River north of Sacramento. The filtration plant processes 340 million gallons a day to supply about 2.5 million residents of Riverside and San Diego counties.

In the early 1990s, MWD embarked on a new reservoir project that is known as Diamond Valley Lake. As mitigation for impacts of the reservoir project and as a result of Riverside County conservation efforts, nearly all of the area between Lake Skinner and Diamond Valley Lake is a large wildlife preserve, where hopefully the horned toads, snakes, birds, and kangaroo rats will thrive along with the native plants.

One

THOSE WHO CAME BEFORE US

Countless generations of Native Americans from the region have songs and stories that tell of their people's creation in the Temecula Valley and migration from there to settle throughout the valley and beyond.

According to legend, Nahachish was a leader of the Temecula people from the beginning of time. He led his people to several locations before they settled at the foot of Palomar Mountain. One version of the story tells of Nahachish leaving Temecula and visiting various villages around Palomar Mountain. After he visited Pala, he decided to return to Temecula and travelled the trail now known as Rainbow Canyon Road. A wicked man envious of Nahachish waited there with his dog to ambush him. When the ambusher saw Nahachish, he fitted an arrow to his bow and let it fly, hitting Nahachish in the belly. Nahachish tried to get down the pass to the spring, but he could not make it, and groaning, he laid down.

The people of Temecula missed him and searched until they found Nahachish near death near the trail. In great pain, Nahachish asked his people to cut open his belly to let his spirit out. As they did, they watched his spirit leave like a giant firefly to Taacwic Rock, near present-day Idyllwild in the San Jacinto Mountains. As his people watched in amazement, Nahachish's body turned into a huge boulder with a massive cavity where his belly had been opened. Through the ages, the giant Nahachish rock has stood in Temecula pass facing the San Jacinto Mountains.

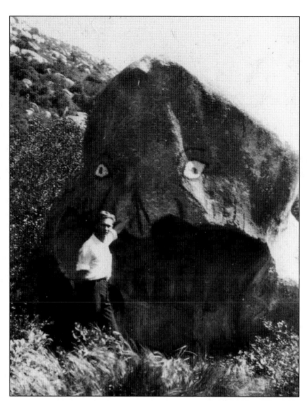

NAHACHISH ROCK. In 1932,
Nawton and Helen Bashaw took
a trip in their Ford Model A on
a picnic date before they were
married. One of their stops was
the legendary rock at Rainbow
Pass on Highway 395, which was a
narrow two-lane road curving up
from the present golf course. While
there, they took pictures of each
other in front of the giant painted
stone. (Both, Bashaw family.)

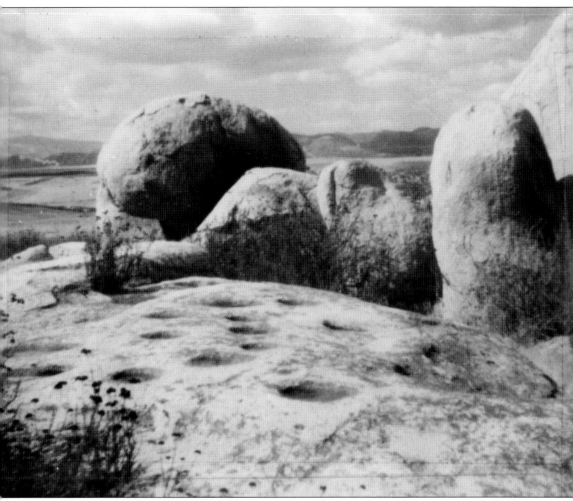

BASE ROCK MORTARS. A large Native American population inhabited Greater French Valley, which is evidenced by the many bedrock mortars (*'éelapalum*) scattered across these hills. The old Marius Nicolas ranch has a site where bedrock mortars were photographed by Frances Nicolas around 1970. Once the holes were started, the Native Americans ground seeds and acorns in the holes for food, using pestle stones to apply the grinding force.

STONE UTENSILS. Luiseño women used pestles and manos to process acorns, seeds, grains, and other foodstuffs in these bedrock mortars. Freestanding metates were also utilized in the same fashion. It is a common belief that metates were portable, but due to their size and weight, they were most likely located near homes and moved only when necessary. A local farmer worked all over the French and neighboring valleys from the 1930s to 1950s and, while plowing, unearthed several of these stone tools left behind by the native people.

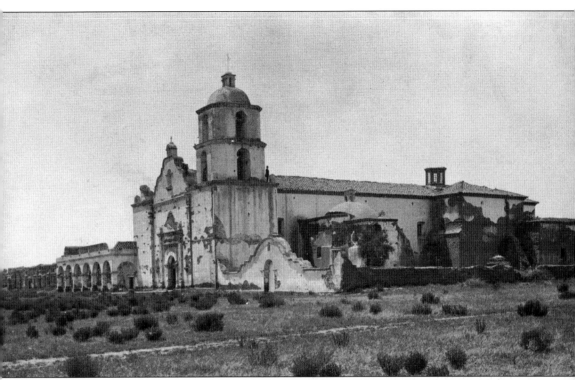

MISSION SAN LUIS REY. The adobe and timber structure at San Luis Rey de Francis Mission in Oceanside was built under Fr. Fermin Lasuen. This was the largest of the 21 missions. The Kumeyaay and Quechnajuicham tribes were rounded up to become neophytes in the Catholic mission. During its heyday, the mission baptized 5,399, married 1,335 couples, and buried 2,718. At the mission's height, the neophyte population numbered 2,788. Its satellite ranchos covered the area from the ocean, which is now Camp Pendleton, to San Jacinto and provided meat, hides, and wool to support the mission. In 1816, an *asistencia* was built at Pala and functioned as a sub-mission to San Luis Rey. In 1834, all the missions were secularized by the newly formed Mexican government, and their holdings transferred to a politically favored few. The missions underwent decay and ruin until the 1890s, when a large restoration effort was started by the Landmarks Club. This picture was taken about 1918, when the mission was at its worst due to weathering and earthquakes. Thankfully it is now restored and is a favorite place for weddings. (Viola Carlson.)

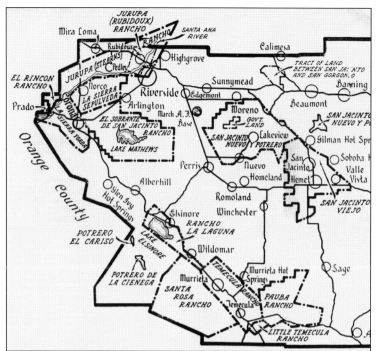

MAP OF MEXICAN RANCHOS. This map reveals bareness in greater French Valley. There are no ranchos and no intersecting property lines, which allowed early settlers to acquire land for themselves in this land that was difficult but beautiful to the eyes of the land-starved masses in Europe. Difficulty and heartache were endured on both sides of the ocean to see countless dreams come true. (Winchester Historical Society of Pleasant Valley.)

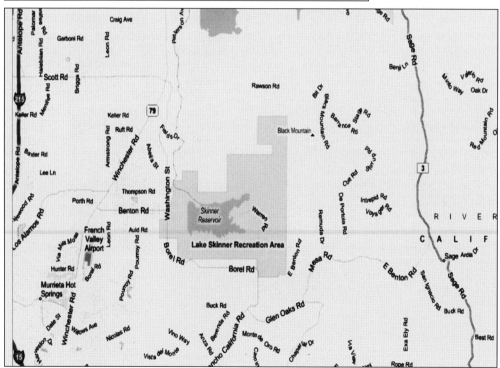

MAP OF FRENCH VALLEY. This map shows the driveways of the early residents, which generally were laid out along the section lines separating their land from their neighbors. Riverside County did not take over maintenance of the roads until after World War II. The roads preserve the names of many of the settlers of this area even though they are long gone.

Two

FRENCH VALLEY

When Joe Nicolas and his fellow sheepherders arrived in the early 1860s, French Valley was covered with chaparral and grass. Homesteaders who followed were faced with hard work and meager living conditions. Just getting here before the railroad came in 1882 involved a long, difficult sea voyage around Cape Horn or walking beside a covered wagon from the east. If one was rich, the stagecoach was an option, but the cost would make one think twice even today.

European immigrants faced the problem of learning enough English to pass the citizenship test, as citizenship was required to homestead land. Once the homestead was filed for, the land was cleared, a home was built, wells were dug, fields were plowed, and the first crop was planted. All was done by hand labor and the help of horses or mules. Many tried and failed, so latecomers of the 1880s and 1890s were able to purchase farms that were owned by those who just gave up. The going price for years was about $5 per acre of farmland. The houses were usually worth $1,500 to $2,000.

This area has always been subject to widely varying amounts of rain, so farmers have always had to save for bad years. Those who didn't suffered during the drought and flood years and lost the farm when they ran out of food and seed. There were no mortgages, so one had to deal strictly in cash to buy land and pay for goods.

Some stores would carry grocery bills on the tab until harvest; the Blackmore Store in Winchester did and had the everlasting appreciation of its clients.

MARIUS AND MARIE NICOLAS WEDDING. Marius made the long voyage to arrive at his brother Joseph's about 1875. In that year, he joined the San Diego County sheriff's posse that drove the Pechangas from their ancestral camp at Pauba Ranch to the reservation. Ten years later, the Jaussaud brothers brought their sister Marie up from their sheep camp in Baja to work for the Nicolases. She married Marius a year later. When Marie Nicolas became an American citizen, her name was changed to Mary.

FREDRIC AND MARIE JAUSSAUD. The Jaussaud parents had this picture taken for their children, who they would never see again. Their sons were sheep herders who were early settlers. Their daughter Marie traveled alone by ship and train with a note pinned to her blouse stating her name and destination in English. Since a sheep camp was unsuitable for a girl of 16, they arranged for her to work for Joe Nicolas. (Evelyn Blackmore DeCou.)

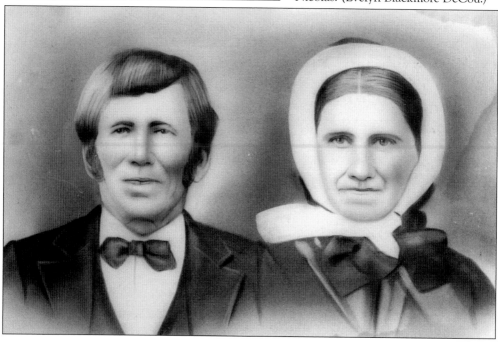

JOSEPH JR. AND SERAPHINA DOMENIGONI NICOLAS. Joseph Nicolas Sr. arrived in the area in 1862 and built an adobe north of Temecula. One of the first young men from France, he became one of the most successful. His son, Joseph Marin, was born in 1886. At his father's death in 1910 at 70 years, young Joe continued ranching and married Seraphina Domenigoni. They had four daughters, Jessie, Margaret, Helen, and Nathaline.

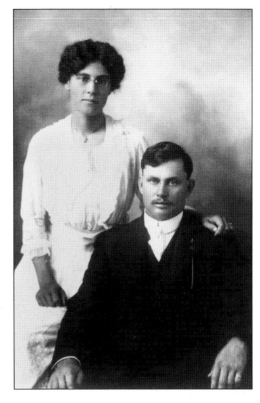

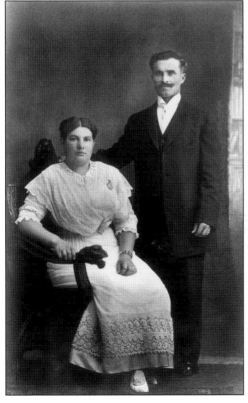

LEON AND CLEMENTINE NICOLAS SERVEL. Leon arrived with brothers from France to settle in French Valley. He married Clementine, the sister of Joe Nicolas Jr. Their first and only son, Leo, died at 9 years with a mastoid infection. Their daughter, Leona, married Carl Preece and lived in Imperial Valley. Leo and Leona attended Alamos School, riding from their home near present-day Sky Canyon Road and Technology Drive.

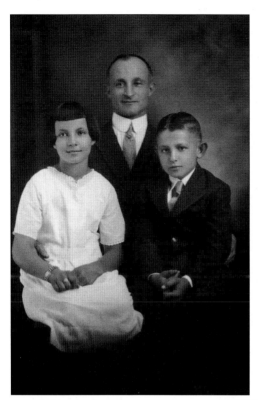

E. CEAS WITH CHILDREN EMILIE AND ALBERT.
Albert grew up to own a large amount
of land and to be an excellent farmer. A
staunch supporter of the Farm Bureau, he
used the latest technology of his day. His
home was at Murrieta Hot Springs Road
and Winchester Road. His mother, Jessie
Nicolas Ceas, died when he was an infant.
His only child, Sherilyn, lives out of state.

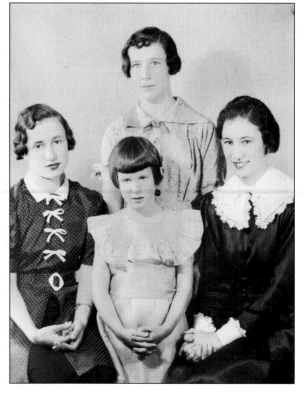

**JOE AND SERAPHINA NICOLAS'
DAUGHTERS.** Pictured from left to
right are Jessie, Nathaline (in front),
Margaret (behind), and Helen.
The girls grew up on the ranch and
attended Temecula schools and
Elsinore High. Margaret married
Melvyn Carnes, who had a garage
in Murrieta, and Nathaline married
Jack Leefer, who raised grain and
turkeys. The Leefer ranch was next
to the Pechanga reservation. Helen
and Jessie married and moved away.

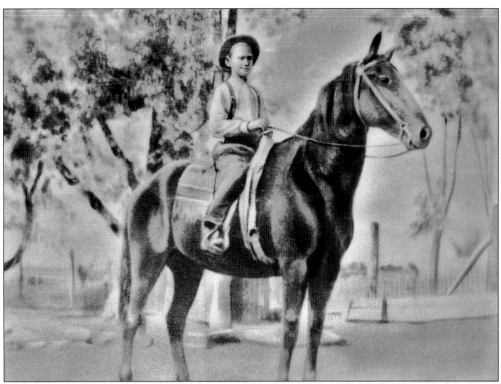

MARIUS A. NICOLAS ON HORSEBACK. Marius lived within 6 miles of his birthplace in French Valley all of his life. His love of horses shines through as he rides to the Alamos Schoolhouse around 1903. He became a stockman, handling great numbers of horses pulling harvesters, and later he used tractors. In 1934, he and his wife, Mary, bought the large South Newport Ranch, where they raised grain and cattle.

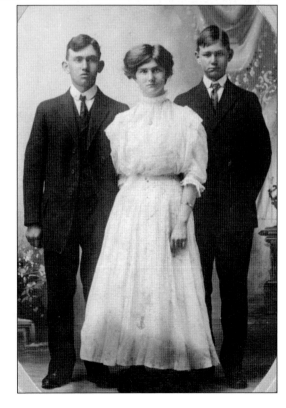

THE THREE NICOLAS CHILDREN. After 10 years of marriage, Marius Nicolas Sr. died, leaving three young children. Marius Alphonse (left), the youngest, was two. Mary married Pierre Pourroy in 1898. As young men, Marius Jr. and his brother, Johnny (right), were farmers, and their sister, Edmee (center), went to a business college in Riverside. Edmee Nicolas married Jim Blackmore, and Marius married Mary Blackmore, Jim's younger sister, in 1914.

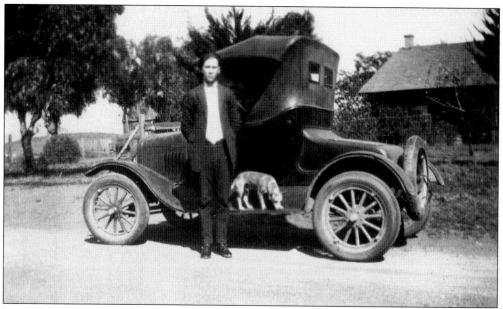

JOHNNY NICOLAS. Johnny Nicolas was an industrious young man. He bought a ranch on Leon Road and worked tirelessly. As a young, handsome bachelor, he had all the girls' attention at dances and other social functions. One hot day in 1917, he came in for lunch and went into a coma. He died a week later from a brain aneurism. (Evelyn DeCou.)

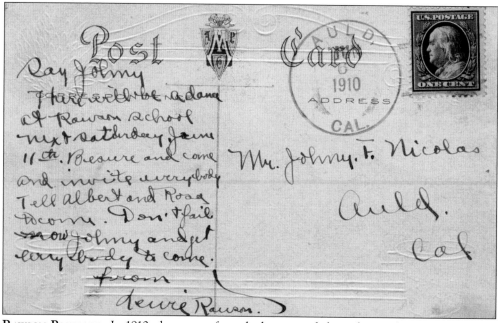

RAWSON POSTCARD. In 1910, there were few telephones, and the only way for most to interact with their neighbors was to go see them or write a letter. The penny postcard was the e-mail of the time. This postcard from Lewie Rawson to Johnny Nicolas was an invitation to a dance at the Rawson School. The trip for Johnny would have been about 5 miles on horseback.

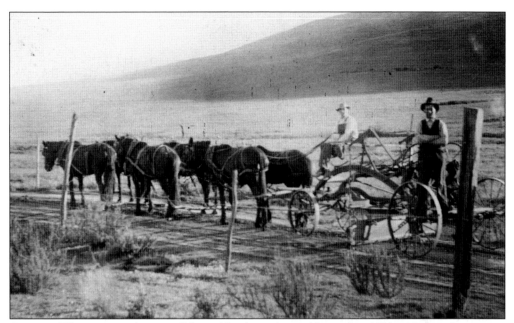

GRADING WASHINGTON AVENUE. Johnny Nicolas is shown (driving) in 1914 grading and preparing Washington Avenue, identified by the *San Jacinto Register* as a county road. The position of Bachelor Mountain in the background indicates they were just north of Benton Road. Farmers kept up all their driveways and roads, since the county assigned those duties to them. (Denise Pourroy Ziony.)

REAPING GRAIN, c. 1910. Before combines were invented, farmers used rigs such as this to mow the grain and load it onto slant-sided wagons for transport to the stationary winnowing machine. Marius Nicolas and his brother, Johnny, had to work as men at an early age after the untimely death of their father. As teenagers, they owned land and farmed for themselves as well as for neighbors. (Edmund Nicolas family.)

ANOTHER VIEW OF REAPER WORKING. Note that the mower was pushed by the horse team and the grain stalks were automatically conveyed to the slant-sided wagon alongside, which required skill from both the horse drivers to keep pace so the conveyer would dump the grain in the wagon instead of the ground. Keeping large teams of horses was hard work because rest, food, and water had to be provided.

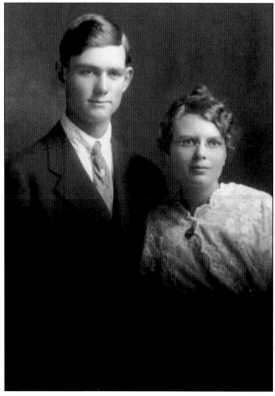

MARIUS NICOLAS AND MARY BLACKMORE. Mary Blackmore followed her brothers to French Valley and fell in love with the tall Frenchman Marius Nicolas, who was an up-and-coming young man. They married on September 30, 1914. They bought the home-place from Pierre Pourroy and Marius' mother, Mary, and lived there for 20 years. The Pourroys moved to another home a half-mile north.

JAMES BLACKMORE AND EDMEE NICOLAS. Jim Blackmore partnered in a wooden harvester with Johnny Nicolas. When able, in 1914, he married Edmee Nicolas, who had gone to business school in Riverside and worked in San Jacinto. She was a valued employee because she could speak French, Spanish, and English. They lived at Skunk Hollow north of Temecula in a modified cook-shack until 1917.

THE BLACKMORE HOUSE IN TUSTIN. This home with 10 acres of oranges was purchased in Tustin soon after Charles and Mary Blackmore arrived from Iowa with their children—Sue, Jim, Everett, Bayard, and Mary—in 1894. The mother, Mary, called Mollie, died soon after from tuberculosis. Jim and his twin brother, Everett, ran away at age 14 and settled in French Valley.

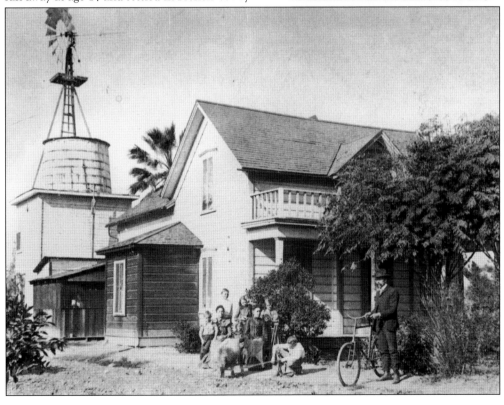

EVERETT BLACKMORE ON BUGGY, c. 1912. Everett and Jim worked for several farmers before Everett bought a homestead in Auld Valley. Everett was injured as a baby and had a hunchback, but that never slowed him down. He was a member of the Auld literary society and enjoyed life. The weather in Auld was too cold, so he moved to Tustin and married Grace Hatfield in 1920. (Edmund Nicolas family.)

BAYARD BLACKMORE AT HIS SISTER MARY'S HOUSE AROUND 1932. Bayard Blackmore, called Bean, followed his brothers, twins Jim and Everett, to French Valley and worked for the farmers in Auld and French Valley. In 1924, he and his brothers bought the Winchester Store. Everyone from miles around shopped there. After the store burned, he and his wife, Eva, moved to Santa Ana. (Edmund Nicolas family.)

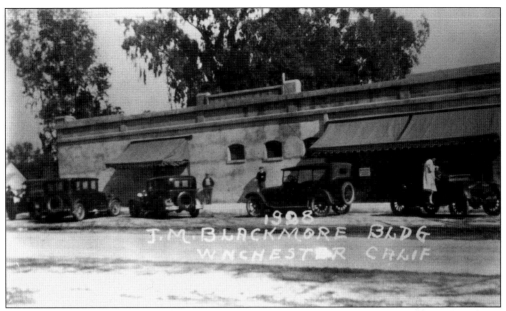

THE BLACKMORE STORE. The Blackmore brothers bought this store from the Lindenbergers. It was a social center as well as the source for food and supplies. Dances were held weekly in the large back room, as well as box suppers, recitals, and meetings. As a general store, it carried food, clothing, ammunition, animal feed, and even repair parts for automobiles and farm equipment. It burned down in 1937. (Evelyn DeCou.)

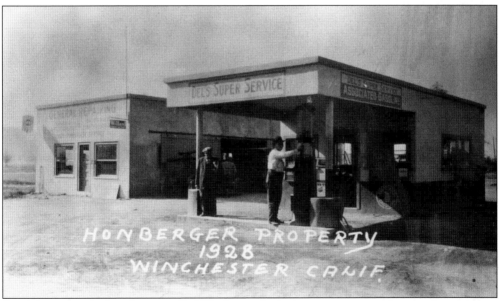

DEL HONBERGER'S GAS STATION. Del Honberger built this gas station and repair shop to serve the Blackmore store customers and local farmers. The repair shop was later turned into a pool hall with beer available. Winchester was founded on the premise that alcohol would never be consumed in the town. Del got around that by posting his notice to sell liquor above the entrance on the inside so nobody saw it. (Evelyn DeCou.)

ICE CREAM PARLOR AND POST OFFICE. This ice cream parlor/post office was built for Everett Blackmore (pictured) in 1927. It operated as such until 1937. When he passed away in 1936, he left three girls and his widow, Grace, to fend for themselves during the Depression. When Jim and Bean's store burned, Grace turned the ice cream parlor into a general store with the same mix of merchandise as the one that burned. It still stands today. (Evelyn DeCou.)

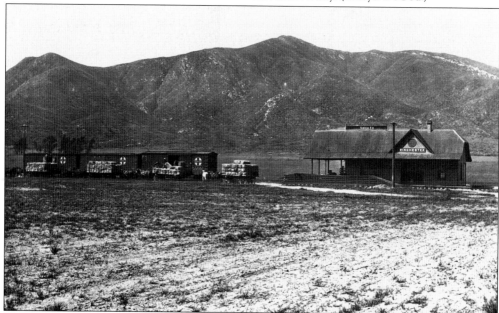

WINCHESTER DEPOT. In 1890, the Santa Fe Railroad built the line from Perris to San Jacinto through Winchester. A stipulation of the lot deed was that a suitable depot be built. French Valley farmers had the choice of meeting the railroad at either Winchester or Temecula instead of taking their crops to L.A. or San Diego with their own wagons.

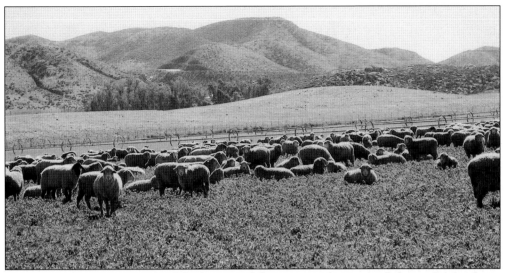

SHEEP GRAZING. Since much of the history of this area revolves around sheep, this herd was hunted up for inclusion in this book. Mr. Valentine, whose home is on Washington Avenue, owns this herd, which he grazes all over Riverside and San Bernardino Counties. They were caught on the old Jim Blackmore alfalfa farm, now owned by the Domenigonis, with Crown Valley in the background.

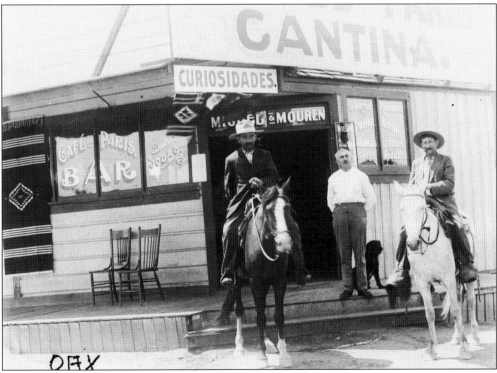

JAUSSAUD BROTHERS CANTINA IN MEXICALI, BAJA CALIFORNIA. Since the Jaussauds were used to herding sheep on both sides of the Mexico border, they were comfortable with buying a cantina and settling down in Mexicali. They still visited their sister Mary in French Valley. Alex Jaussaud lived in French Valley for several years. (Evelyn DeCou.)

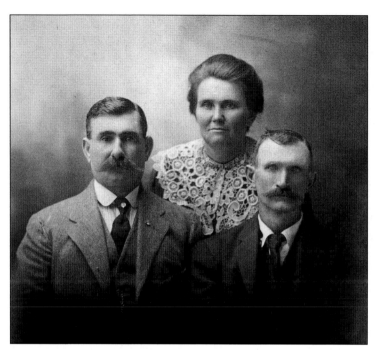

ALEXANDRE J. JAUSSAUD, C. 1915. Alex Jaussaud (left) was a pioneer of French Valley, and though he loved the area, he left and moved to Calexico for 25 years. His sister Mary and Pierre Pourroy looked forward to his visits. This rare photograph shows Pierre clean-shaven. Pierre's granddaughter Denise had never seen him without a full beard until she saw this picture.

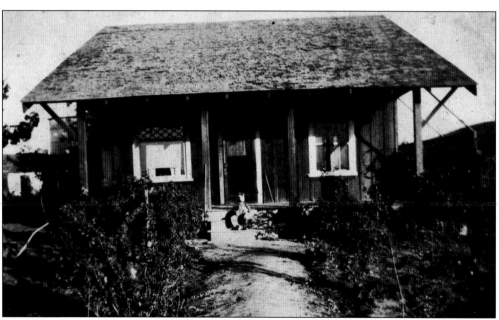

POURROY HOME. Upon their marriage in 1898, Pierre and Mary moved to their home on Beeler Road, later named Pourroy Road. In 1914, they sold that house to Mary's son Marius and moved to this home. This house was built in 1907 of board-and-batten single-wall construction with handmade square nails. She had it plastered and upgraded so that it was an exceptionally warm, comfortable home. (Denise Pourroy Ziony.)

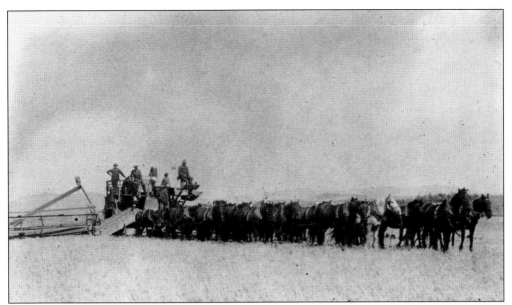

HARVESTER WITH HORSES. In 1915, Pierre Pourroy and his sons owned this combine harvester. All of the blowers and shakers inside the machine used to winnow the grain from the chaff, cut the grain, and convey it were run from the wheels. The motive power was 24-32 horses. The workhorses were powerful animals driven by a skilled horseman. (Denise Pourroy Ziony.)

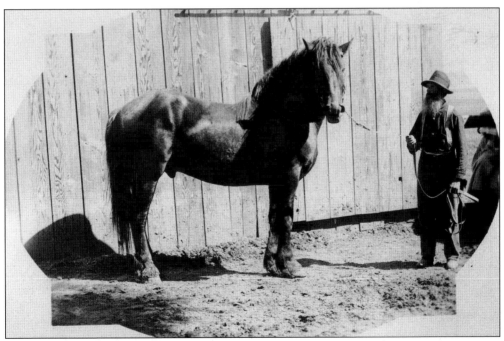

GARMEN. Pierre Pourroy paid Rob Cummins, Marius Nicolas, and others $1,200 for this purebred Percheron stallion, shipped from France in 1918. At that time, $1,200 was more than a year's earnings for most ranchers. Garmen was the sire for Pierre's workhorses and for many of the neighbors', so his bloodline was well represented as long as workhorses were used. (Denise Pourroy Ziony.)

THE POURROY CHILDREN. Mary and Pierre Pourroy had four children: Bertha, center; Fredric (Fred), right; Pierre (Pete), left; and Albert, the youngest, who, at the time of this photograph, had not been born yet. Albert tragically died at 16 in a farming accident. Bertha married Ed Streeter. Fred married Frances Bashaw and had a large ranch on Leon Road. Pete married Catherine Bidart and purchased his parents' home on Pourroy Road. (Denise Pourroy Ziony.)

AT HOME. Thanksgiving 1937, in the middle of the Depression, was a happy day for the descendants of Mary Jaussaud, Nicolas Pourroy, and Pierre Pourroy at the old family home on Pourroy Road. The families of Edmee Nicolas Blackmore and Marius Nicolas, Fred and Pete Pourroy, and Bertha Pourroy Streeter were represented. The Blackmore-Jaussaud-Pourroy-Nicolas reunion is still held every year.

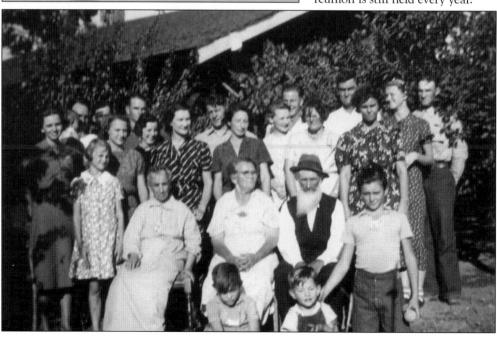

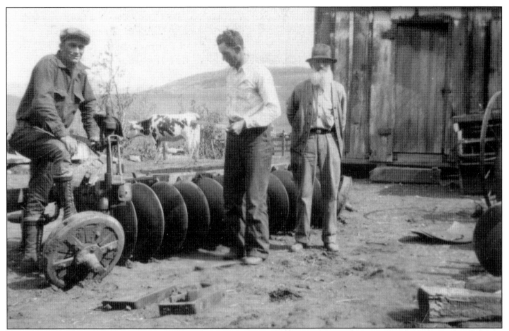

Disc Plow. The hard rocky ground took its toll on the metal discs used to till the soil. Pete Pourroy looks at the camera as his brother Fred studies the disc and their father Pierre looks on at Fred's place. Replacing the discs occurred often, especially when new land was prepared for crops. Professional help meant a trip to the blacksmith shop in Winchester. (Bashaw family.)

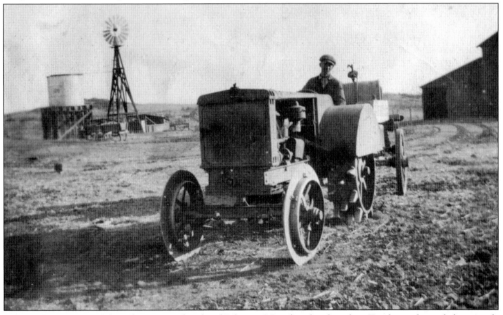

Fred's Tractor. After the tragic death of Johnny Nicolas, his brother Fred purchased the ranch from Mary Pourroy and farmed it for the rest of his life. Fred, like his father Pierre and son Ronald, was progressive and continually upgraded his equipment for efficiency. Note the steel lugs on the drive wheels and the narrow wheels in front. Before power steering, steering almost broke one's arm. (Bashaw family.)

EDMEE BLACKMORE AND MARY NICOLAS. These sisters-in-law are expecting double cousins at the same time. Harvey Blackmore and Frances Nicolas were born at their respective homes days apart in 1919. Harvey farmed for years at his Blackmore ranch in East Murrieta, which is now the site of a housing development called California Oaks. (Bashaw family.)

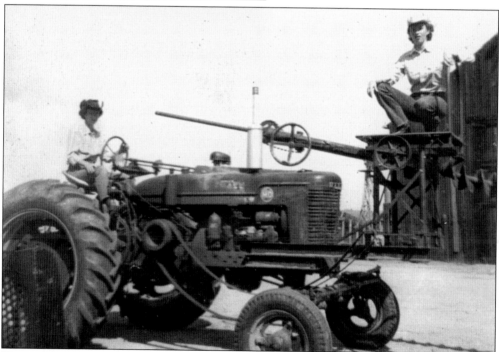

NANCY BASHAW AND DENISE POURROY. Denise Pourroy (right) was an only child, but the farm labor expected of her was the same as for a man. She and Nancy attended Alamos School and were charter members of the 4-H club supervised by Dorothy McElhinney. Pete Pourroy modified this tractor to dig post holes for fencing. Denise and her cousin Nancy were assigned the job of digging rows of fence post holes. (Evelyn DeCou.)

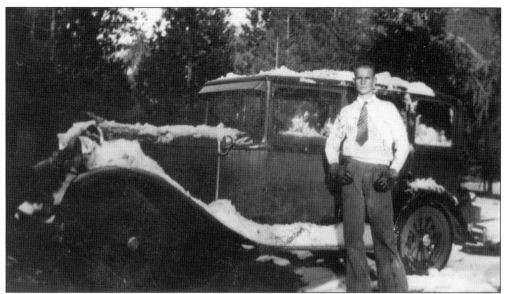

EDMUND NICOLAS WITH CAR IN SNOW. The 1933 Ford V8 that replaced this car was coveted by Ray Graves, the foreman of the 2,800-acre South Newport Ranch. With $500 and the V8 down, Marius and Edmund Nicolas entered escrow with $7,000 due at harvest. They worked day and night to get the land planted. They brought in a great crop and were able to meet that year's note. (Edmund Nicolas family.)

BEHIND THE WHEEL. Frances Nicolas is pictured behind the wheel with her brave cousin Leona Servel. Both girls are Alamos School alums, but Frances just graduated at 14 from Hemet High, and Leona, also 14, has years to go. Because of Frances' early start, great intelligence, and an older brother to egg her on, schoolwork was a snap. Teachers allowed her to skip grades. She sat out a year and then attended Riverside City College. (Courtesy Edmund Nicolas family.)

OLD RED BARN. Henry K. Small built this barn about 1894 on his land, which was to become the Marius Nicolas ranch as time passed. In 1900, he sold the ranch to William Newport of Menifee and moved to Riverside to open a nursery and seed company, which was very successful. Small's son Leon loved red barns, so it was painted red for over 100 years.

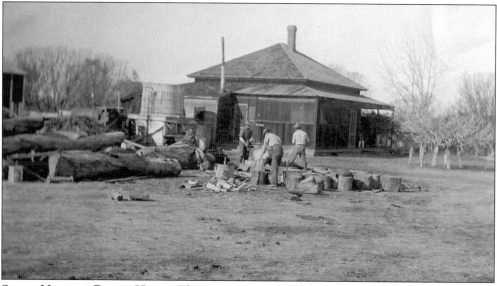

SOUTH NEWPORT RANCH HOUSE. This picture was taken after William Newport purchased the H. K. Small property. Newport had settled in Menifee Valley and expanded for a short time into French Valley. He built a bunkhouse and other barns that all burned in the firestorm of 1993. Wood was the only source of heat for cooking and space heating. Men are chopping wood for the year. (William Newport Collection.)

MARIUS NICOLAS AND HARVEST CREW. As time passed, Marius Nicolas (right) graduated from 32-horse rigs to ever more powerful tractors and harvesters. By 1940, when Alexander Borel took this picture of his neighbor, Marius was leading an impressive crew harvesting his 3,000 acres of land. Marius was known as a fair and generous employer, and many men returned to his crew year after year. (Borel family.)

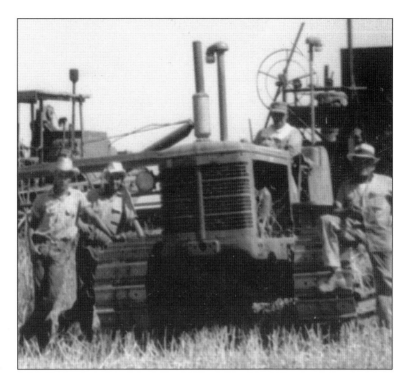

ROAD THROUGH NICOLAS RANCH. Cattle are peacefully grazing alongside the primitive Buck Road about a mile south of the present-day filtration plant. Roads looked like this from the 1920s to the 1990s, when many finally got paved and renamed. This stretch is no longer open, as the Johnson Ranch Ecological Preserve closed it to public use. (Borel family.)

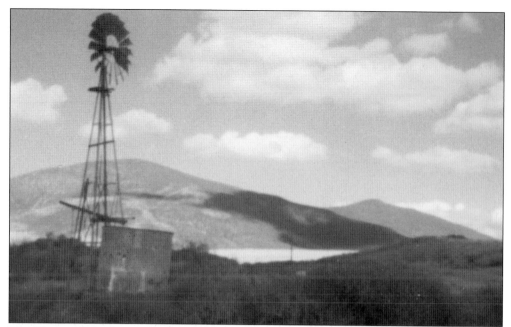

THE HARVEY WINDMILL. John Harvey owned a nice piece of property for years at Auld and Borel Roads. He sold his land to Marius Nicolas, and for years his windmill pulled up fine water for the stock that grazed in the fields. Here ground is just being broken for the MWD filtration plant to the right, and Auld Valley is yellow from harvest years before Lake Skinner.

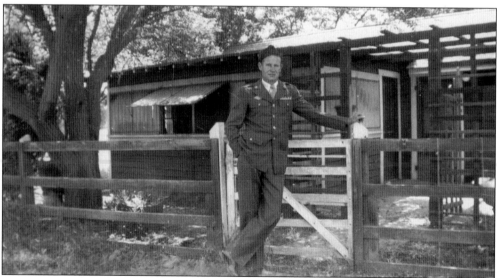

DEAN RICE IN UNIFORM AT THE GREENWOOD PLACE. Mr. and Mrs. Greenwood built their home in 1915 and lived there sporadically for years until they sold the property. Dean Rice married Frances Nicolas on December 31, 1945, and they moved into the house. The well went dry in 1950, so the house was moved to Benton Road, next to Frances' parents. They raised turkeys and reared four children: twins Mary and Dean and daughters Irene and Randy.

Turkeys. In 1950, Dean and Frances Rice joined the popular profession of raising turkeys. The J. C. Loomis Turkey Show was evidence of the many farms in this general area that succumbed to the prospect of riches through turkeys. Dean worked hard at raising the birds until his death in 1964. The bronze turkeys tasted better than the white birds, which took over the industry because they didn't have dark pinfeathers.

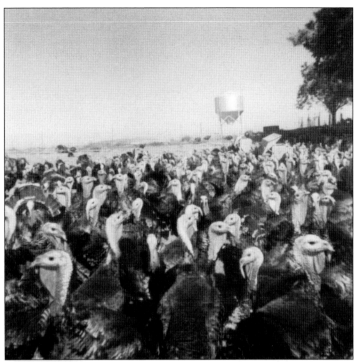

Marius and Mary Nicolas with Grandchildren. The honeysuckle had many pictures taken in front of it at the Nicolas' old ranch house. "Mammy" and "Pappy" Nicolas were loving grandparents to their seven grandchildren. Pictured here from left to right are Irene Harris, Dean, Marius with Randy Rice on his lap, and Mary with her hands on Mary Rice's shoulders. The grandchildren not pictured are Jean, Betty, Penny, and Judy Nicolas.

FRED AND FRANCES POURROY. The Pourroy house was built by Johnny Nicolas around 1910 and served as the home of his sister, Edmee, and Jim Blackmore until 1924, when they bought the store in Winchester. Fred and Frances Bashaw Pourroy then bought the ranch and raised two sons, Ronald and Fred. (Barbara Pourroy.)

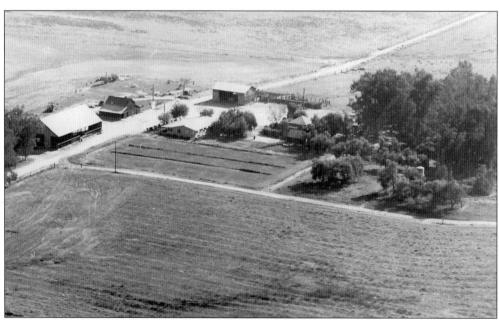

NICOLAS RANCH. This view was taken in the 1960s at Benton Road and Washington Avenue. It was a working ranch for many years, dealing in grain and cattle and pasturing horses during the winter. Johnson Tractor Company bought a large part of the ranch in 1964. The Metropolitan Water District purchased land for the San Diego pipelines and the filtration plant. A small amount of land remains in the family today.

POWER LINE . Most of the greater French Valley received electricity in 1947. This area was covered by the Perris District, and men like these risked their lives. "Mike" Menifee Wilson (right) worked for the Southern Sierras Power Company, which changed to Cal-Nev for a short time and then California Electric Company before Edison took over. Homes in the Sage area "out in the hills" were still using generators into the 1950s.

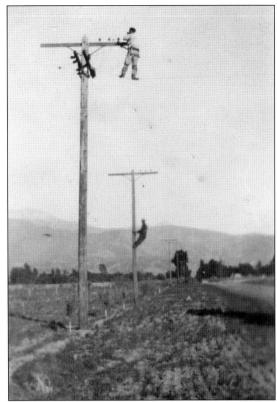

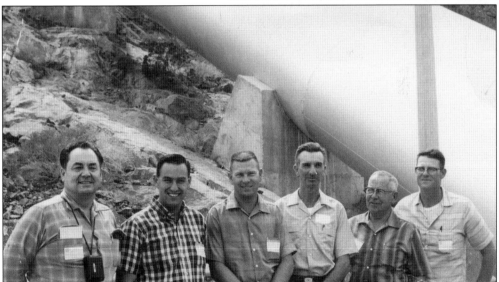

FIELD TRIP. This water adventure took place on the Colorado River in1965. Pictured from left to right are Clyde Christensen, unidentified, Frank Endres, Chester Morrison, unidentified, and Alex A. Borel. The unidentified men are employees of Metropolitan Water District of Southern California. The tour showed the farmers of the area the mighty water resources being harnessed in huge pipelines heading their way. With the use of towers and gravity, water flowed to San Diego without the aid of a pump. (Frank and Loretta Endres.)

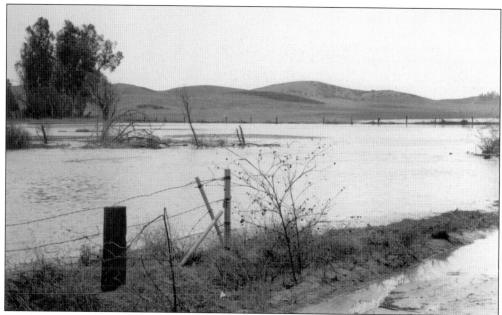

THE FLOOD OF 1993. Flood waters cover the old Cantarini place looking southeast from Pourroy and Winchester Roads. Very early pioneers, the Cantarini family came from Switzerland and was in the sheep business about 15 years before expanding. This property was later farmed by Robert Cummins and Karl Frick, owner of the former Jean Nicolas place to the east. Hard work allowed him to bring his brother, Eugen, and family from Germany in 1955. (Conrad Frick.)

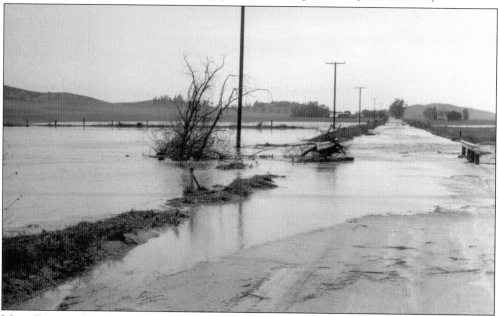

MORE FLOOD. This photograph was taken by Conrad Frick, the first American-born son of Eugen. It looks south toward his family's home to the right owned by Pete Pourroy. His sister, Borghild, 11 years old, loved Dora Fjeld, who taught her English with her siblings after school. She said, "I didn't know I had an accent until High School! The Alamos students embraced the Frick family as their own. (Conrad Frick.)

40

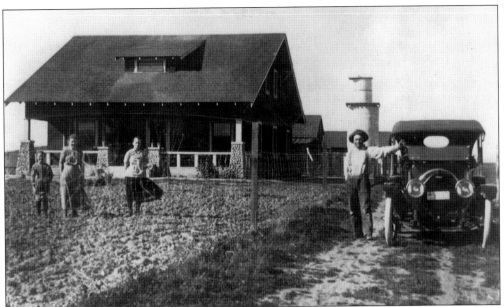

THOMPSON HOUSE. The Thompson family arrived by train around 1885. They stayed with cousins, the Garringers. This house was built by Joseph Vance Thompson in 1913. It had a cement veranda with rock pillars from beach rocks picked up by their grandfather, George C. Hind. The house was powered by a carbide plant that proved too expensive, so they turned to kerosene lamps. The story goes that Grandpa's beard was so long that granddaughters had to carry the candle upstairs. (Dorothy Rail Taylor.)

THOMPSON RANCH. The three-quarter section had never been tilled until the Thompsons' 12-inch plows went to work along Thompson Road. They worked the Joe Nicolas property and others. Their daughter Edith married A. K. Small; his brother, H. K. Small, built the Newport Ranch. Joseph V. Thompson and his children attended the Alamos School, both in the first building and in the one built *c.* 1900. (Dorothy Rail Taylor.)

Rob's Wedding Photograph. Robert Matison Cummins was born in Kansas in 1881. He came to California with his family. When his father died in 1900, all schooling stopped, and he began working odd jobs to help the family. By the time he was 25, he was able to buy land in French Valley—160 acres from Nancy Axe for $1,600. Rob's mother and brother had homesteaded in Auld Valley. (Carl and Betty Rheingans.)

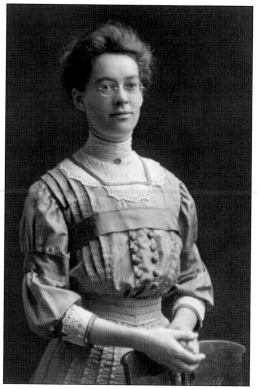

Pearl's Wedding Photograph. Hattie Pearl Dickinson had a teaching job, so she traveled from New Hampshire to live with her brother, Frank, in Riverside, but the job fell through, and she found herself teaching at the Hyatt School in the middle of nowhere. The bright spot besides the children was the Literary Club of French and Auld Valley, where she met Rob Cummins. They married on August 30, 1911. (Carl and Betty Rheingans.)

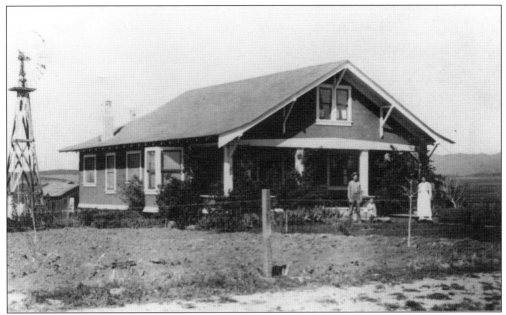

CUMMINS HOUSE. Cecilia Cummins visited her brother in Nebraska. The newlyweds lived in her house for the first year while Rob and his brother Bert built a house across the street from the Alamos School. Walt Cooper and Jessie Sheld Cooper took baby Joan with them across the street to a dance at the school, and she ran out of milk around midnight. He and two others helped themselves to Rob's dairy cow, and Joanie slept through the night. (Carl and Betty Rheingans.)

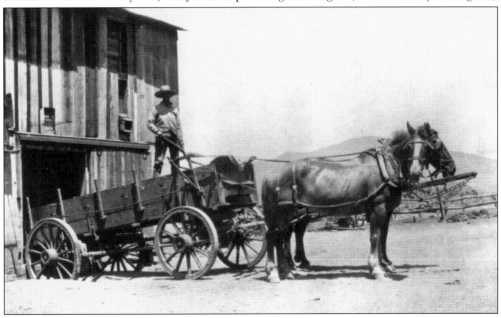

CUMMINS GRANARY. Cummins Granary was the first in French Valley. No longer did the Cumminses have to fill gunnysacks, tie them closed, and stack them on the wagon. Handling and hauling the grain in bulk enabled Rob to re-clean it and to store it in a safe, dry place. It might be seed for next year's crop, or he might just want to wait until the price is right. His granary gave him a choice. (Carl and Betty Rheingans.)

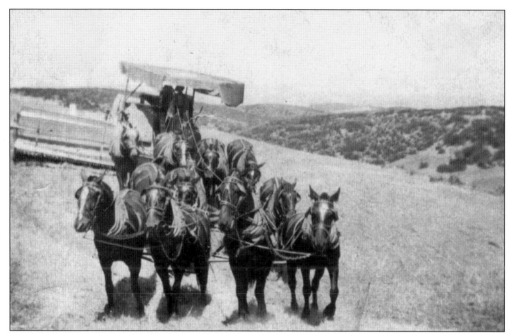

WOODEN HARVESTER. Rob and another farmer in French Valley, James Blackmore, purchased a horse-drawn Holt Harvester together. They worked together, harvesting their grain and doing some custom work. In 1924, James Blackmore and his two brothers partnered together and bought the Winchester Store. (Carl and Betty Rheingans.)

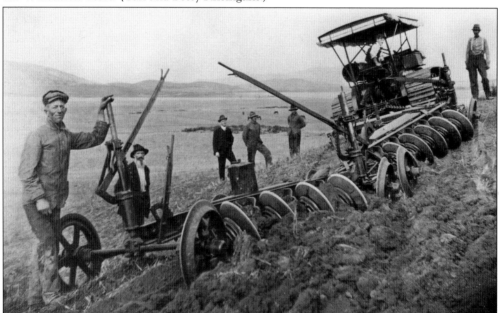

SERVICE FROM SALESMEN. The Holt tractor is delivered to Robert Cummins, who is standing behind the tractor with suspenders. This grand day, January 1, 1918, saw the newfangled horseless contraption out in Rob's field to see what it could do. In the audience, besides the salesmen, are Alexander G. Borel (not shown) and Pierre Pourroy (second from left), among others. This machine was ahead of its time and worked tirelessly. (Carl and Betty Rheingans.)

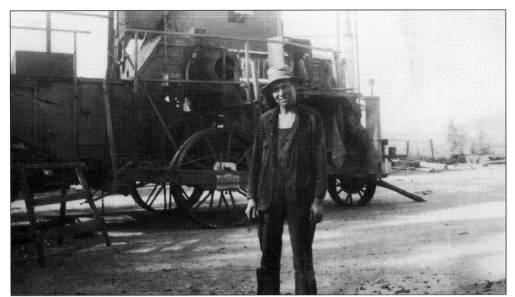

HELPFUL BROTHER. This wooden harvester needed to be rebuilt before the next harvest season. Brother Bert (pictured) came to Rob's rescue and fixed it up good as new. His great-nephew Carl Rheingans, a collector of fine equipment, kept this fine machine safe under the eucalyptus trees until the saplings grew though the ancient vessel and some had the nerve to consider it junk. Carl hauled it away in 2008. (Carl and Betty Rheingans.)

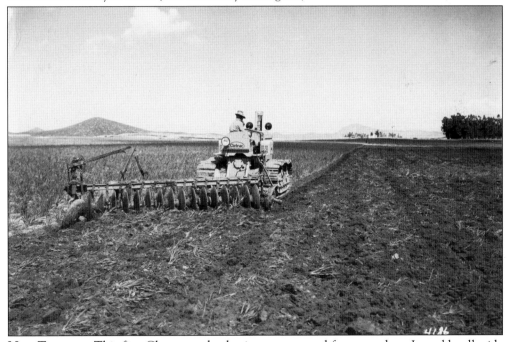

NEW TRACTOR. This fine Cletrac made plowing an easy and fast procedure. It could pull wide discs that went deep into the ground. A great-grandson of Robert and Pearl Cummins still farms but does it a state away with the aid of trusted employees (one started to work with his father in 1974) and a computer, sitting at the kitchen table. In just a generation, farmers have dwindled to a handful. (Carl and Betty Rheingans.)

CUMMINS FAMILY. Pictured from left to right are (first row) Robert Cummins and his wife, Pearl; (second row) Carol Cummins Powers, Bobby Cummins, and Helen Cummins Rheingans. All three children attended Alamos School for eight years and went to college. Helen taught at Winchester, and Carol and her husband lived in Vermont and later Laguna Beach with their family. After college and being married a short time, Bobby was drafted into the navy, became ill, and passed away suddenly in 1945. (Carl and Betty Rheingans.)

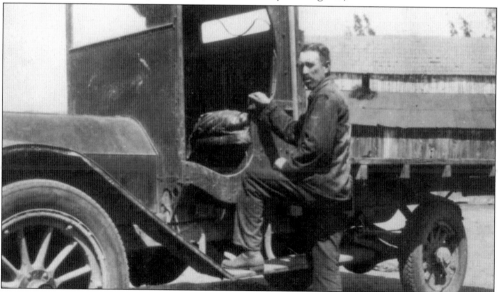

HOMEMADE TRUCK. Like his father and brother, Robert (above) was very innovative. He designed and built this truck from scratch, making it fit the needs he had around the ranch. He broke horses with his soft voice and he was respected by all of his neighbors, working well with them and helping Dora Fjeld with her concerns with the school. For over 30 years, he and Pearl had Dora Fjeld as a boarder and then a neighbor. (Carl and Betty Rheingans.)

ENDRES MODIFIED WINERY. For 13 years, Frank and Loretta Endres lived in a modernized Quonset hut moved from Camp Haun until they turned the small winery they purchased in 1963 in French Valley into a home. They kept the original walls that formed the 1,800-square-foot structure and added 600 more. The floor was built below ground with a slope of one to three feet for drainage. The construction process included resetting and leveling the floor, breaking through 10 inches of reinforced solid concrete to make windows, and drilling holes and other passages for electrical outlets. (Endres family.)

The Endres Home. Their home was the former Fontana Brothers Winery, built approximately 40 years earlier by industrious brothers with a dream to have a vineyard by dry-land farming methods. They planted acres of fine wine grapes. The shallow hand-dug wells, approximately 45 feet deep, did not provide the water needed. The original winery was divided into three parts: a central unlighted storage area with sloping floor, a work area with several windows, and a retail room off the winery's north side. The Endres family farmed in French Valley for 40 years and continues to dry-land farm near Corning, California. (Endres family.)

Three

MORE FRENCH VALLEY

The Borels were known for their awareness of the environment and ability to manipulate soils and planting seasons for optimal growth of their grain crops. The success of a farmer's crop required being aware of both harmful and beneficial insects as well as their natural predators. Having water was a contributing factor to the success of the Borel Ranch. Alexander G. Borel purchased two of the springs in French Valley, Adobe Springs along Warm Springs Creek and A Waca Del Media along the Tucalota, which the Borel families still own. Several men worked for the Borel Ranch in exchange for a water well drilled on their properties to support their own families. Sixteen of the wells capped by the local water district in Historic Downtown Murrieta bear the Borel name. The use of the springs and creeks of the area were the basis of a lawsuit, *The United States of America v. Fallbrook Public Utilities District et al.*, where the *et al.* portion included the property owners of French Valley. The lawsuit was never completely settled and is more than three million pages long. Although the majority of the Borel ranching operations have moved to Northern California, French Valley's Borel Ranch is still occupied by Borel family members today.

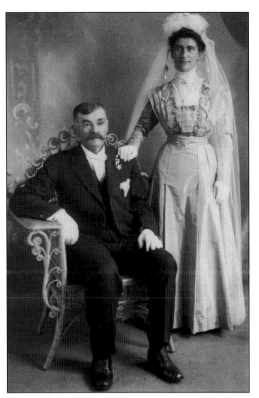

ALEXANDER GILBERT BOREL AND ROSALIE MARIE ALLEC. By the age of 47, Alex had established himself in French Valley as a farmer, miner, and blacksmith of the area, owning over 1,000 acres. During visits to Murrieta's Guenther Hot Springs, he befriended Ben Kraemer of Placentia, who introduced him to his wife's unwed sister Rosalie; both were from neighboring towns of the Haute Alpes of France. In June 1909, Alexander Gilbert Borel and Rosalie Marie Allec married. (Borel family.)

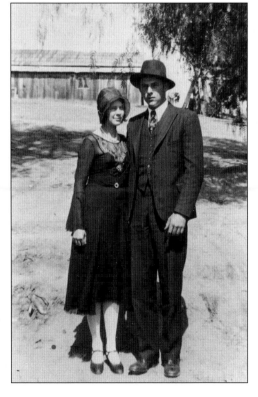

ALEXANDER FREDRIC BOREL. Rosalie and Alex G. Borel had one son, Alexander Fredric Borel, who married Louise Allison Allen of Murrieta in October 1930. Unlike his father, who spent the majority of his life as a bachelor, Alexander F. Borel took over his aging father's 1,000-acre ranch at the age of 17 and married at the age of 20. They had two sons, Alexander Allen Borel and David Leon Borel. (Borel family.)

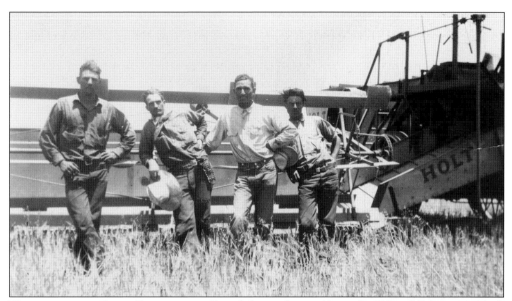

HARVEST ON THE BOREL RANCH 1931. From left to right are Alexander F. Borel, Johnny McKhul, Nic Gamez, and Gilbert Helms. Alex F. Borel was well known for lunging forward during droughts and depression, reorganizing property ownership, and bringing in new equipment, which eventually increased the size of the Borel Ranch with his sons and grandsons from 1,000 acres to over 10,000 acres of land. (Borel family.)

DOVE SEASON. Hunting was a way of life in French Valley. Every September, the Borels held a dove season party in their barn. From left to right are David Leon Borel, Alexander F. Borel, Bill Kraemer (in front), Judge Vernon V. Hillard, Scott Borel, Dick Bumbstead, Tom Bumbstead, and Murphy Lovering. Note the pile of grain beyond the hay bales. (Borel family.)

THE PICKING CIRCLE. The picking circle provided a moment of bonding on the Borel Ranch between the youth and the experienced. For the children, it took focus to remove every little pinfeather while listening to tales of the hunt of the day and of days past. Clockwise around the circle from the top are Alex F. Borel, Alex A. Borel, Bill Kraemer, Alex Ray Borel, Martin Lovering, Leon Borel, and Scott Borel. (Borel family.)

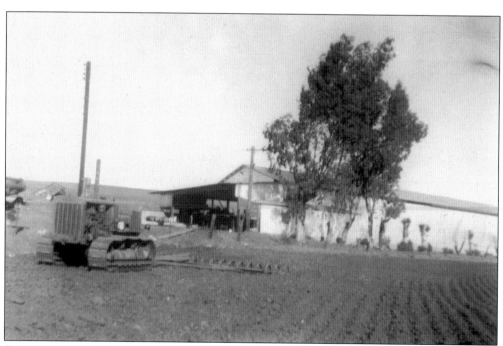

SELF-SUFFICIENT. When the men came in from the field or finished filling the Borel barn with over 100 tons of grain or had a hard day of welding and repairing equipment, a cold beer could be found in the taproom of the Borel barn, fully equipped with a walk-in icebox that often held several sides of beef and a lamb or hog or two. (Borel family.)

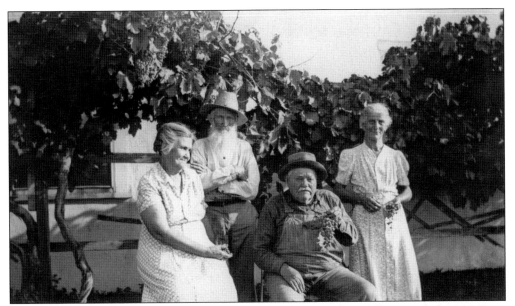

GRAPE HARVEST. The Borels, like many of the other French families of the area, made wine. From left to right are Mary Jaussaud (Nicolas) Pourroy; her husband, Pierre Pourroy; (sitting) Alexander G. Borel; and his wife, Rosalie Allec Borel, posing with some of their crop, from which they made different wines. The two families enjoyed mixing their individual varieties of grapes in order to produce different wines.

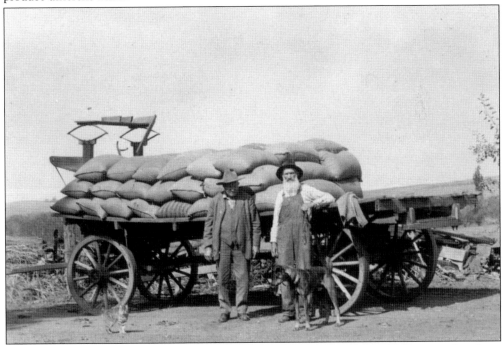

STACKING GRAIN. Alexander G. Borel (left) and Pierre Pourroy stand with the grain they have sacked and stacked on the wagon for market. Large barns and grain silos became the moneymakers for many of the local farmers, allowing them to sell portions of their crops at better prices later in the year rather than having to sell it all at once and flooding the market.

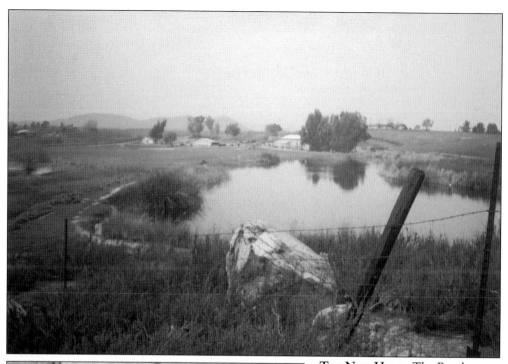

THE NEW HOME. The Borel Ranch headquarters is at the corner of Borel and Leon Roads. The original home of Rosalie and Alex G. Borel was on the west side of what is now Winchester Road near Adobe Springs until they moved closer to their other spring, A Waca Del Media. Their new home, pictured above, was built in 1920 by Eli Barnett, the same man who built the First National Bank of Temecula. (Borel family.)

WAITING FOR DOVES. Louise Allen Borel, Alexander F. Borel's wife, sits on the steps waiting for a dove to fly by. Her hunting tag is pinned to her collar. In fact, it was nothing for a farmer's wife to walk out to the chicken coop and wring the neck of a young rooster to cook up for dinner that night. (Borel family.)

BRAND -69-. The majority of cattle on the Borel Ranch were polled Herefords, with the brand 69 first registered by Alexander G. Borel. As California grew, the ranch was asked to elaborate on the 69 to make further distinctions between it and another brand, so at the beginning of the 20th century, -69- became the Borel Ranch trademark; it remains so today.

PLUCKING DUCKS. Alexander F. Borel's two sons, Alex A. (left) and D. Leon (also known as Toy and Spider) pose with their ducks alongside the barn. Moments later, the two of them would stoke up a fire to boil soapy water and soak the ducks before plucking them clean to cook for dinner. (Borel family.)

THE SLED. On another day, Alex A. (left) and Leon (center) would hook Mike the plow horse up to "the sled" and head off to Judge Hilliard's place. On this day, one of the judges' nephews (right, unidentified) was there, and the three had just started playing when Toy and Spider (the boys) were told to find their way back home. (Borel family.)

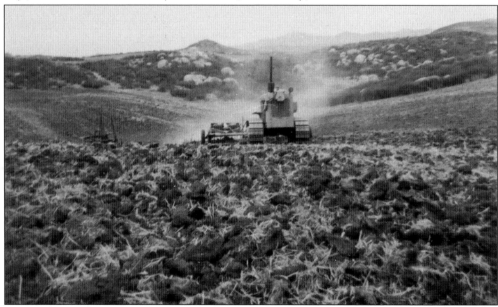

TRACTORS. From 1925 to the early 1970s, the Caterpillar tractor was the mainstay on the Borel Ranch until replaced with Steiger tractors. The Steiger could plow up to 100 acres a day in comparison to Caterpillar's 40 acres a day. The rich red clay and loam soils of French Valley were perfect for the area's dry-land farming. (Borel family.)

TIME FOR BEER. The taproom in the barn was where the crew would meet after work for a cold beer. It was a gathering place for friends or for plucking ducks over a smudge pot on a cold winter morning. The Borel Ranch barbecues often started there with the slaughtering of a lamb and the warming of French tourtons, and there were always cheese, crackers, ice-cold fruit, and slices of moose salami on hand. (Borel family.)

VOTE JUNE 6

ALEX A. BOREL

CONSTABLE

Murrieta Judicial District

QUALIFICATIONS:

Deputy Constable — 4 years
Member of Marshal and Constables Specia
Academy & Association
Special Deputy Sheriff — 12 years
Educational Director — 13 years

Law enforcement is to help people.

THE THIRD GENERATION. Alexander A. Borel, an accomplished farmer, worked off the ranch for a short while doing soil science and conservation work for the O'Neal family, which owned the Mission Viejo Ranch. Alex also sat on California's Agricultural Advisory Board for the Department of Agriculture for many years, but he prides himself most as being a helpful friend. (Borel family.)

THE VITICULTURIST. David Leon Borel pursued agriculture as well, although it was not in dry-land farming but rather the citrus groves of the Kaiser Company of Rancho California, which were later transformed into the vineyards of today's Temecula wine country. He was an award-winning viticulturist who owned and operated French Valley Vineyards. (Borel family.)

JUDGE HILLIARD. The Honorable Vernon V. Hilliard took office on June 12, 1950, as the first judge of the Murrieta Judicial District. He also held court in French Valley, exactly 1 mile south of the current Southwest Justice Center near his home on Borel Road, now part of Borel Ranch. The Borels sold the properties for both the French Valley Airport and the Southwest Justice Center to Riverside County. (Borel family.)

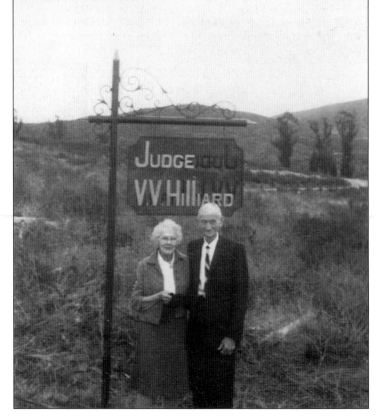

ALAMOS SCHOOL. The first Alamos School was built on Jean Nicolas' property around 1889. San Diego County controlled school affairs until 1893, when Riverside County was formed. This *c.* 1905 picture shows the second Alamos building on the property donated by the Pefley family. The 4-acre site is at Pourroy and Benton Roads. (Denise Pourroy Ziony.)

HOMEMADE ANGEL. Rachael Thompson's mother made these wings for her part in an Alamos School Christmas play around 1918. Being the only girl that year, Rachael had three parts to play. The Christmas program was the highlight of the year for the students preparing and performing. The local literary club also produced an annual play for a community fund-raiser using community talent.

AULD POST OFFICE. The Auld home was the post office from 1899 until the post office was moved to the Bert Cummins home in Auld Valley. Here the Cecilia Cummins house has the sign "Auld Post Office," as she became postmistress around 1922. She homesteaded in Auld near her son Bert. Her house was moved kitty-corner from the Alamos School. Before long, everyone used the post office in Winchester. From left to right are John Throop; Helen, Carol, and Bobby Cummins; and Ruth and Jane Throop. (Carl and Betty Rheingans.)

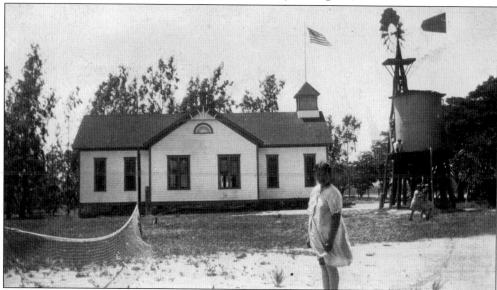

SADLY ALONE. Mary Alvarado stands on the east side of the schoolhouse. Her father was tragically killed when a load of grain he was hauling down a steep grade tipped over. Her mother, a Lopez, moved with her children, Mary and Angelo, to her parents' home near the Jean Nicolas place on Washington Avenue north of the Temecula Preparatory and Charter Schools. Her grandfather, a Spaniard, worked for Jean Nicolas and the Nicolas brothers.

60

GOOD FRIENDS.
The three Alamos
students, Merle
Thompson (left),
Alex Borel (center),
and Edmund Nicolas,
were from the largest
farming families
in French Valley.
Games for all ages
were necessary in a
one-room school, as
there may have only
been a few students
in a grade, one
student, or none at
all. The age difference
did not hinder
these youngsters in
becoming the best
of friends. Edmund
was the only boy
at Alamos for a
couple of years.

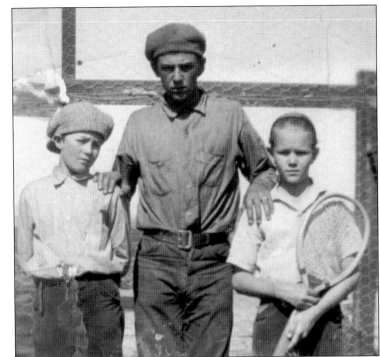

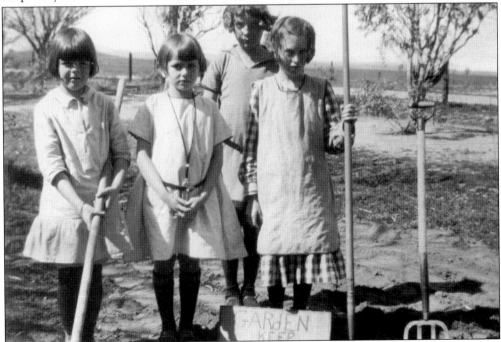

GARDENING AT RECESS. From left to right, Lucille Thompson; Frances Nicolas; Leonnie Sterns, whose mother was a Vial; and Carol Cummins are working hard to put in a garden at the Alamos School. The ground doesn't look exactly fertile. A small school with between 5 and 12 students allows creative and enjoyable ways to spend the recesses and lunch hour. There just weren't enough students for a team sport.

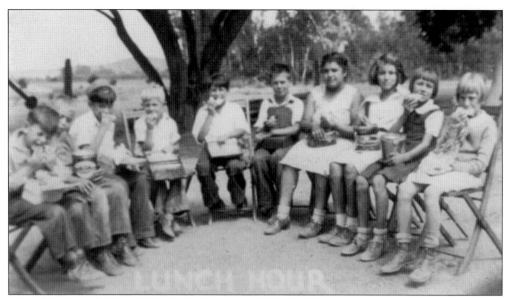

LUNCH HOUR. This lunch hour photograph, taken in 1933 under the valley oak tree on the east side of the school, has the words "Lunch Hour" stamped in the dirt. From left to right are Billy Auld, John Speziali, Ronald Pourroy, Clarence Dashner, Freddie Fogerty-Sparravohn, Dick Holland, Mary Alvarado, Judith and Thelma Special, and Ruth Holland. The Speziali family lived north of Bachelor Mountain. Fred Pourroy was absent the day of the photograph.

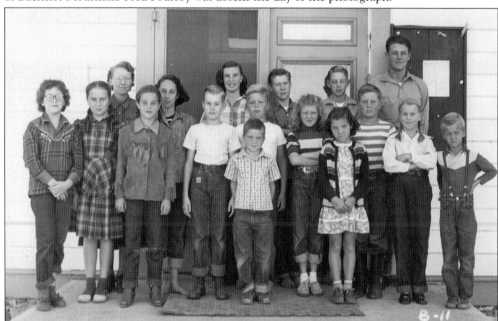

1949 STUDENTS. Alamos School in 1949 included, from left to right (first row) two unidentified, Lois Huls, and George Lindeman; (second row) Barbara Auld Sewell, Irene Harris, Judy Guenther, James Huls, Andy McElhinney, Vivian Ridgley, and Fred Guenther; (third row) teacher Dora Fjeld, Nancy Bashaw, Denise Pourroy, Bobby Carlson, Leon Borel, and Alex A. Borel. Two years before, Hyatt School closed down for lack of pupils, and Bobby Carlson was the only student left who transferred over.

ALAMOS IN THE SNOW. The Alamos School was a jewel among the many area one-room schools at the beginning of the 20th century. The date above the door indicates it was built in 1900, but Helen Cummins Rheingans, the school historian, believes Alamos was built a few years before that. The school's floor plan is larger than most, built with solid redwood, a stage, and carbide lights. (Bashaw family.)

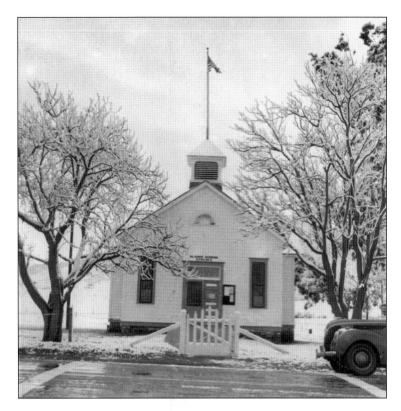

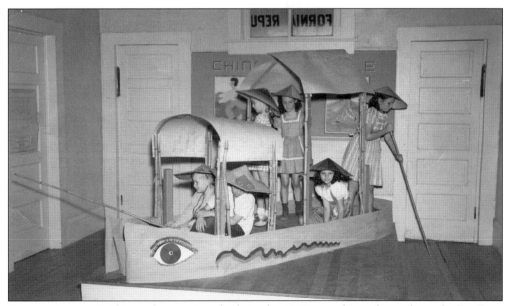

FISHING ANYONE? This student project, built in the 1940s, taught students about the Far East. This Chinese junk boat is made of paper and cardboard and sits on the teacher's platform. From left to right, Leon Borel, James Huls, Irene Harris, Nancy Bashaw, Sherilyn Ceas, and Denise Pourroy enjoy the adventure during geography.

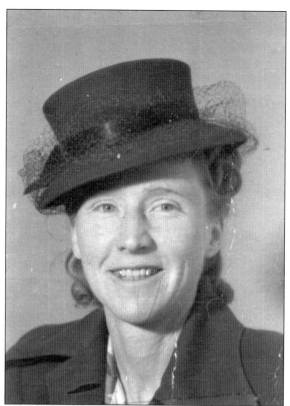

MISS DORA FJELD. Dora Fjeld lived in Escondido and went to a common school for her teaching certificate. For the next 37 years, she lived across the street from Alamos in Rob and Pearl Cummins' house and then in a very little aluminum trailer in their yard. She began teaching in 1930, was dedicated beyond measure, and was respected by all. Her heart and soul were totally focused on the welfare of the students.

1955 STUDENTS. One of the largest student bodies in Alamos history included, from left to right (first row), Dean Rice, Tony Guenther, Danny Sewell, and Alan Bashaw; (second row) Mary and Randy Rice, Linda Morris, Wade Sewell, and Draza Knezevich; (third row) Nancy Chelette, Mary Kay Austin, Carol Sewell, Milica Knezevich, Eugene Hill, and Carl Guenther; (fourth row) Judy Guenther and Dora Fjeld. The next year, Alamos joined the Hemet school system and went to six grades.

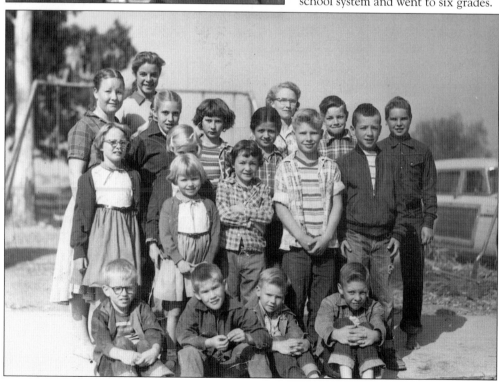

Four

AULD VALLEY

Auld Valley was a rare combination of natural phenomena that made it green and lush when the rest of the Greater French Valley was dry and brown. The Tucalota Creek ran year-round in the late 1930s and early 1940s and was joined by Rawson Creek and Middle Creek on the Auld property just west of the Roripaugh ranch. All these streams carried large amounts of silt and organic matter down from Sage and Crown Valley in periodic floods, making the soil very rich and the water table from 4 to 6 feet below the surface.

It was ideal farmland, because almost anything could be raised there by dry farming. George Auld Sr. recognized the potential and arranged for his family to buy or homestead contiguous parcels of land at the west end of the valley. The east end of the valley was owned by L. L. "Doc" Roripaugh and Tommy Rawson.

Jim McBurney bought Doc Roripaugh's ranch in 1937 with the dream of raising dry-farmed watermelons, as he was sure they would be sweeter. He paid $4,000 for 640 acres, of which about 90 acres was bottomland and the rest chaparral-covered hills. He borrowed money from friends such as Helen Rheingans to finance the venture. The only problem was that all the melon growers in Southern California had a bumper crop, setting the price offered by the produce markets in Los Angeles at 1¢ a pound. After picking and hauling the crop to Los Angeles, Jim lost his investment and the money borrowed. The entire valley is now covered by Lake Skinner and the wildlife refuge.

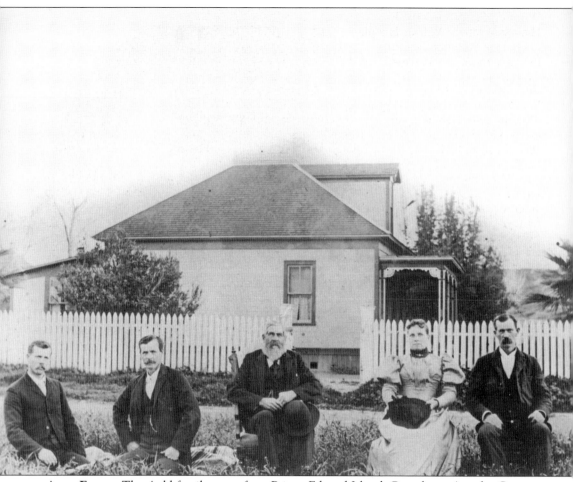

AULD FAMILY. The Auld family came from Prince Edward Island, Canada, to Amador County, California, for the gold rush. In 1880, they settled in the valley that bears their name. From left to right, Charles, Henry, George Sr., Eliza, and William H. Auld are shown in the yard of their home. They started the Auld ranches, which eventually covered 1,700 acres. William H. ran livestock and dry-farmed grain; Henry farmed and raised Morgan horses. Eliza was a schoolteacher at Menifee School; Charles kept bees, turkeys, and cattle. The land remained in the family for 84 years, until it was bought by MWD for Lake Skinner. In 1902, William H. married Emily Dee Higgins in Murrieta. They had George H. (born 1907) and Alma. George H. married Mabel Ann Kirk and had William Kirk (born 1927) and Barbara. Billy Auld was a mainstay of Alamos School, where George Auld was a trustee. (William Auld family.)

William H. Auld and Emily Dee Higgins Wedding. William H. Auld was born in Volcano, California, in 1854. He and his father, George Sr., recognized the value of the Los Alamos Valley and homesteaded 320 acres after George gained citizenship in 1868. In 1898, H. K. Small petitioned for a new post office to serve Los Alamos, and it was approved for the Auld home. (William Auld family.)

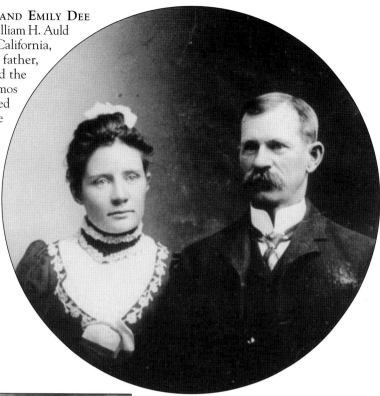

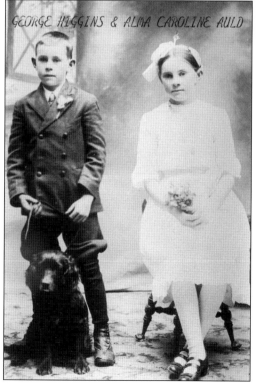

George Higgins and Alma Caroline Auld. George H. Auld was born in 1907 in Auld, California. He leased 80 acres to his neighbor, Jim McBurney, for melons in 1938. He was a friendly person as well as a prosperous farmer known for the civic duties he volunteered for. He was killed in a traffic accident in San Bernardino in 1941, leaving a widow and two children. (William Auld family.)

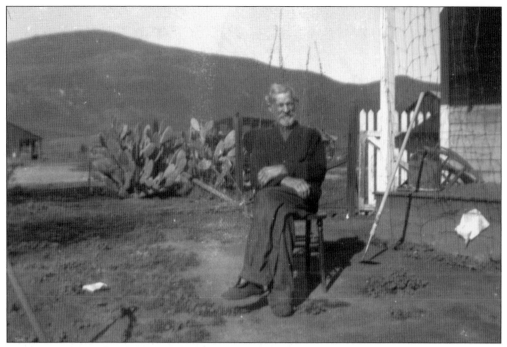

WILLIAM H. AULD. William H. Auld died in 1945 at his beloved ranch, where he had lived since 1880. He is shown warming in the morning sun in 1944 with Bachelor Mountain behind him. At age 90, he had seen progress from horses to tractors and modern machinery. (William Auld family.)

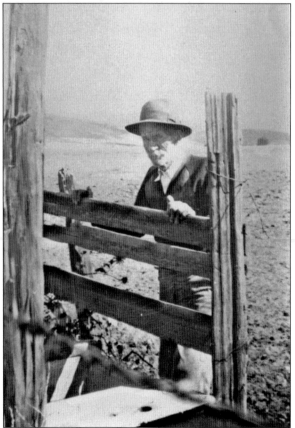

LOOKING OVER THE FENCE. During William H. Auld's life, one of the only ways to get to California was by sailing ship, as his family did. He was a blacksmith for several years near Santa Cruz and for three years in Riverside before moving to Auld Valley to join his family in 1880. (William Auld family.)

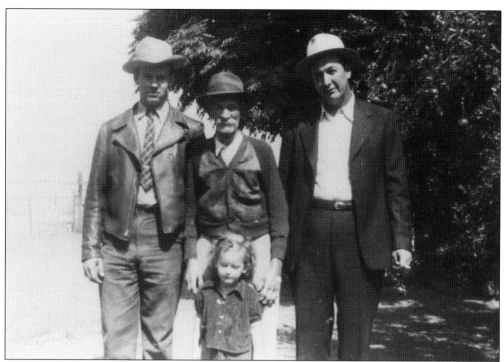

THREE GENERATIONS. Bill Auld (left) is pictured at age 15 with stepfather Harold Sewell (right); grandfather William H. Auld, age 88; and sister Barbara Ann Auld Sewell at the Auld Ranch. Bill's mother Mabel had remarried after George Auld's death. Bill and Barbara both attended Alamos School. (William Auld family.)

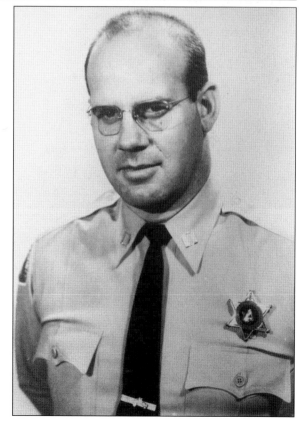

SHERIFF AULD. William Kirk Auld was a Riverside County sheriff until 1964, when MWD bought the ranch. He attained the rank of captain of detectives. He bought a farm in Amador County, within 30 miles of his grandfather's previous home, where he was a cattleman, captain of the mounted search and rescue posse, chairman of the county farm bureau, and director of the cattleman's association. (William Auld family.)

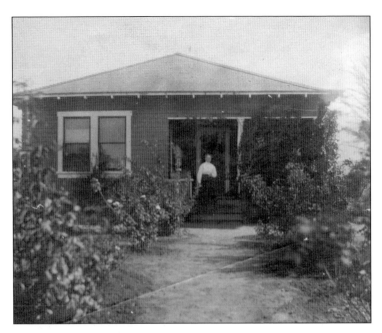

CUMMINS HOUSE. Bert Cummins' house was built in 1902 on 320 acres in Auld Valley. The next year, Bert married Jennie Bell Munger of Dehesa in San Diego County, where the Cummins family had lived. Around 1917, Bert sold his property and bought an apartment building opposite Exposition Park near the USC campus in Los Angeles. Bert was a carpenter by trade, and he and Jennie loved to travel. (Carl and Betty Rheingans.)

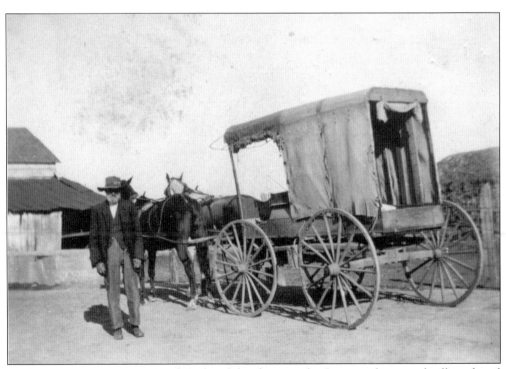

FRANK SURBAUGH. For years, Frank Surbaugh lived next to the Cummins house and collected mail to and from Auld and Winchester. He also picked up groceries for those en route and provided taxi service at the Winchester Depot. A timid 25-year-old schoolteacher from New Hampshire, Pearl Dickinson, rode out to her first job at Hyatt in 1910. (Carl and Betty Rheingans.)

FLOYD BUCK AND JESSIE PIERCE WEDDING. Arthur E. Buck and his brother, Sherman O., settled in Auld Valley before the turn of the 20th century. They built fine ranches and the Hyatt School for the education of the children in the area in 1899. The school was moved to its final location in 1905 by George Baisley. Jessie and Floyd, Arthur's son, were married on May 6, 1917. (Marge Trunnell Hearell.)

HARVESTING GRAIN. Art Buck and Lincoln Pierce harvest grain with a 24-horse team around 1900 at Buck Mesa near the present intersection of Buck Road, Glenoaks Road, and Rancho California Road, about 3 miles south of Lake Skinner. Art is driving the team from the flying seat on the end of a pole. Lincoln is running the machinery. The large Buck family went to Hyatt School when Clara Robertson taught there. (Marge Trunnell Hearrell.)

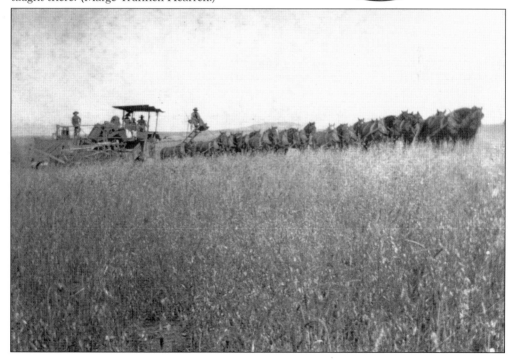

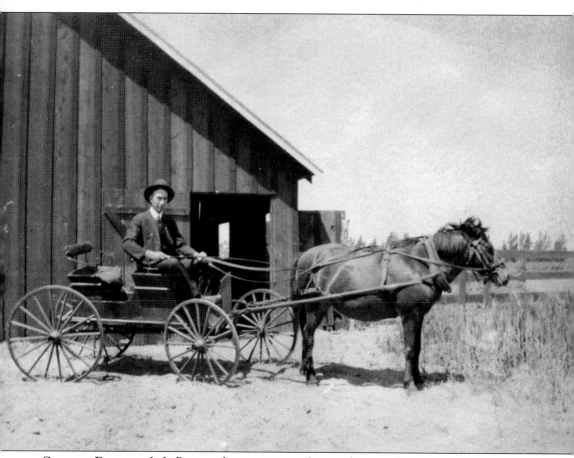

COUNTRY DOCTORS. L. L. Roripaugh was a pioneer doctor who served patients the old-fashioned way by going to them in his buggy. With no phones, someone had to go to the doctor's house and find him to come to their home to minister to the sick. At times, babies were delivered by family members and the doctor would show up later to sign the birth certificate. Dr. Roripaugh farmed 640 acres at the east end of Auld Valley. Most of his business was setting broken bones. Dr. Iner Sheld-Ritchie (above) attended Loma Linda and worked as a medical missionary in southern Mexico for man years. He helped establish the Flying Doctors of Mercy. The Ritchie Memorial Clinic near Veracruz, associated with Loma Linda, was dedicated to his memory. (Sheld family.)

HONEYMOONERS FOR 65 YEARS. James R. McBurney and Lena Eiland McBurney are pictured on their honeymoon in June 1927. The Depression hadn't started, but financially strapped Jim and Lena took the first step of their 65-year marriage by eloping to San Bernardino the day after she graduated from Hemet High School. He is remembered by French Valley old-timers as the man who delivered Signal oil products to their tanks one bucket at a time. (Elaine McBurney Wilson.)

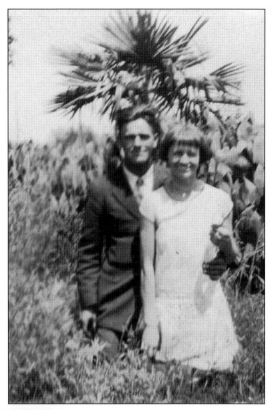

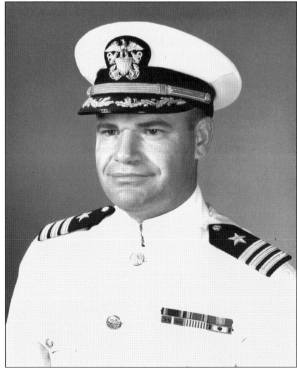

COMMANDER MCBURNEY. William James McBurney was the firstborn of Jim and Lena's three boys. He attended Hyatt School in 1938 and loved his teacher, Elizabeth Conrad. Later, during World War II, the family lived in Winchester, where the teacher was Alta Rice. Both of these dedicated women prepared William for life and higher education at the master's level. (Elaine McBurney Wilson.)

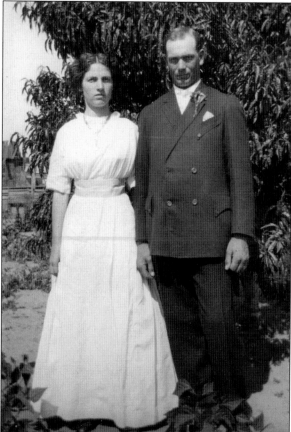

COWBOYS. After their mother died in 1893, the children of Leander Sheld were placed in an orphanage; Dan was 5, and he left at the age of 11. Stin was in a foster home and later worked as a cowboy, then a foreman. By 1912, they all got together at the Pioneer Ranch near Corona as cowboys. From left to right are Stin, Bob Allison, Dan, two Netherall boys, and Iner Sheld-Ritchie. (Sheld family.)

DANIEL SHELD–LULU ABBOTT WEDDING. In the spring of 1914, Dan Sheld was offered the job of foreman of the harvest crew by William H. Auld if he could find a cook for the crew. Dan rode to Corona, where he proposed to Lulu by saying "if you will marry me, I can get us both jobs." She did, and they got the jobs. Gibbel Hardware in Hemet furnished their house for $90. (Ellen Sheld Milholland.)

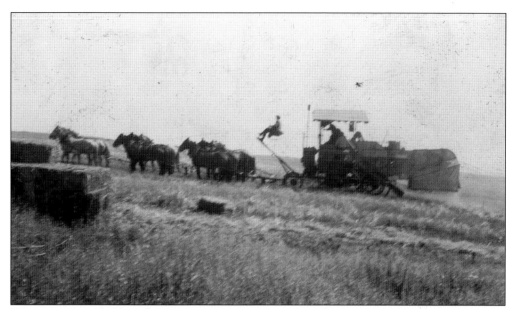

TEAMSTER. Dan Sheld was known as an expert teamster from driving loads of fence posts down the Idyllwild mountain grade many times. This was hazardous, because friction brakes were just blocks of wood against two of the wagon's wheels. He bought his first ranch in 1924 from Dr. Roripaugh and drove large teams to harvest his grain while sitting on the trapeze seat. (Sheld family.)

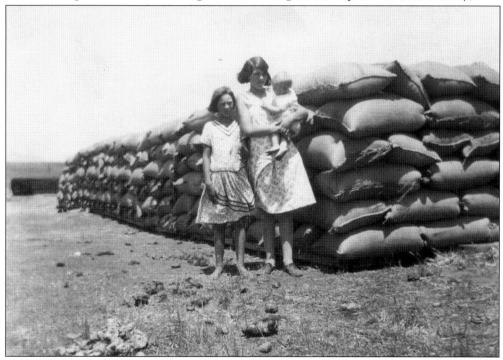

SACKS OF GRAIN. Sheld girls Mary (age 8) and Ellen (age 14), holding Lulu Marie (age 1), pose at the Buck Place in front of the fruits of a year's effort for their father, Dan Sheld. Mary is barefoot, and all are in homemade dresses made from flour sacks. The family discovered Lulu Marie was born deaf when she was three. (Ellen Sheld Milholland.)

PUTTING UP HAY.
It took a lot of hay to feed the Sheld animals for the winter. Pictured in 1936, Marlen Sheld (age 13) is gathering hay, which involved a lot of physical labor. All farm boys did a man's work in those days for the privilege of getting regular meals. At that time, allowances were not even considered by parents. (Sheld family.)

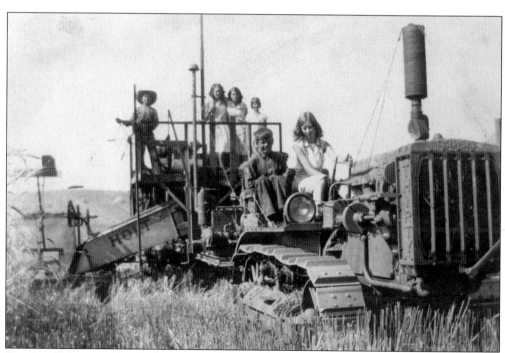

KIDS ON TRACTOR. The Sheld family was proud of their ability to farm in the difficult climate that broke so many. Part of their success was buying modern equipment when it showed a clear advantage over the existing gear. It was a moment of familial joy when Dan took delivery of this 1930 Caterpillar tractor. From left to right are Bud, cousin Jessie, Ellen and Virginia, with Sherman and Mary in the driver's seat.

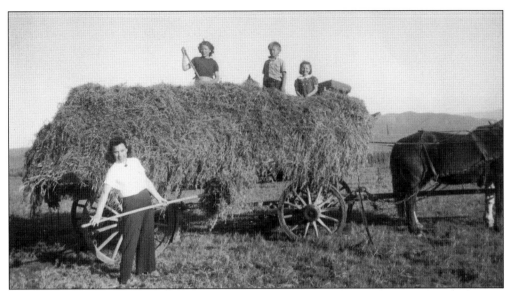

ELIZABETH CONRAD AND HAY WAGON. Sherman Sheld courted Elizabeth Conrad, the Hyatt teacher, and married her at the end of the 1940 school year. The day she applied for the Hyatt job, he had seen her while up in the windmill repairing it; he said to himself, "I'm going to marry that girl." She was fun-loving and right at home with all the Sheld children. On the wagon from left to right are Virginia, Jimmy, and Phoebe Sheld. (Elizabeth Sheld.)

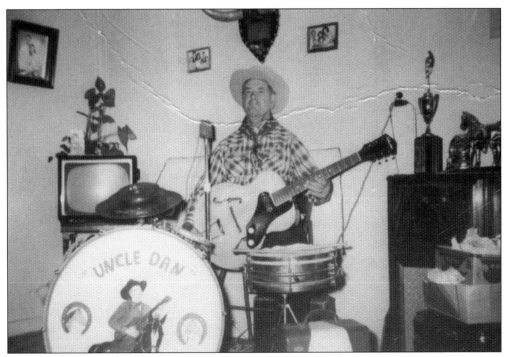

DAN THE ONE-MAN BAND. Dan Sheld, on his retirement from farming, kept busy with his true love of entertaining. He was well known as a one-man band capable of playing harmonica, drums, and guitar at the same time. He would also sing and call square dances. He played at home parties, school dances, and even on the radio. Along with music and horses, Dan loved his family best.

MR. AND MRS. BUTTON. Jess and Lola Button bought their ranch on the mesa south of the Tucalota Creek next to the Rawson Brahma cattle range at the north end of Lake Skinner in the early 1900s. Jess had family living in the area. Mostly they lived in Los Angeles, where Jess owned a livery stable and a mortuary. He was known for wearing a three-carat diamond stickpin everyday in his overalls.

THE BUTTON HOUSE. Fearing fire and earthquakes, the Buttons constructed a reinforced concrete house in 1911 that still stands, although the roof has rotted away. The house was home to several families over time. In 1941, it was the home of Richard and Ellen Milholland, and Nawton Bashaw later lived there. Here Robert Milholland runs across the yard. The Buttons had a small house south of this main house that they stayed in when they visited. (Ellen Sheld Milholland.)

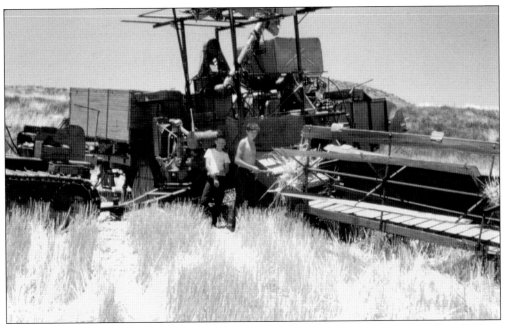

HOT SUMMER DAY. In another demonstration of children being responsible workers, Alan Bashaw and Jerry Milholland, ages 11 and 13, drive the tractor and run the combine at Nawton Bashaw's Button Ranch to harvest the 1957 grain crop. The land they are harvesting is east of the new location of the Alamos Schoolhouse at Lake Skinner. (Bashaw family.)

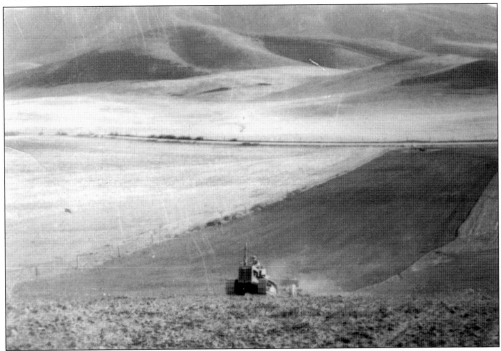

SCENIC FARMLAND. Nawton Bashaw is plowing his 40 acres at the bottom of Auld Valley about 1955. Note the rich earth that was covered by the waters of Lake Skinner. Today, the place where he plowed is just off the boat landing at Lake Skinner. (Bashaw family.)

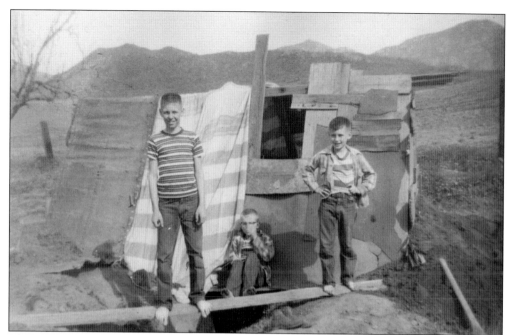

HARD WORK HAVING FUN. Children made their own play equipment and if they weren't watched could do dangerous things like digging tunnels. Alan Bashaw (left), Dean Rice (center), and Joel Bashaw thought it would be fun to dig a cave for a clubhouse and pretend to be pirates, cavemen, or just stay cool in the summer heat. It kept them busy for a few days that year. (Bashaw family.)

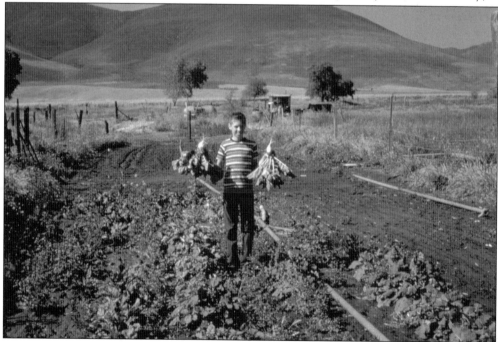

PRIZE TURNIPS. Nawton Bashaw proved once again the rich bottomland that made up Auld Valley by raising a kitchen garden down next to his grain field. Note Bachelor Mountain in the background. Nawton's son, Alan Bashaw, is holding large turnips with copious greens. (Bashaw family.)

MONSTER TRUCK. The 1970s brought changes never thought of before World War II. Penny Sue Nicolas Smith operated heavy equipment for the building of Diamond Lake Dam. With power steering and brakes, the skills of driving such a behemoth were well within the ability of intelligent women, and they performed them excellently. (Penny Sue Smith.)

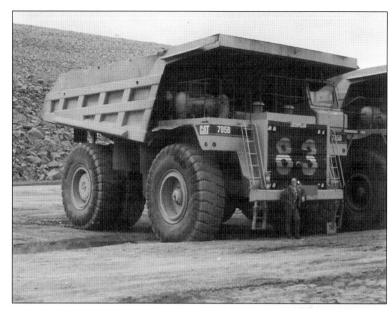

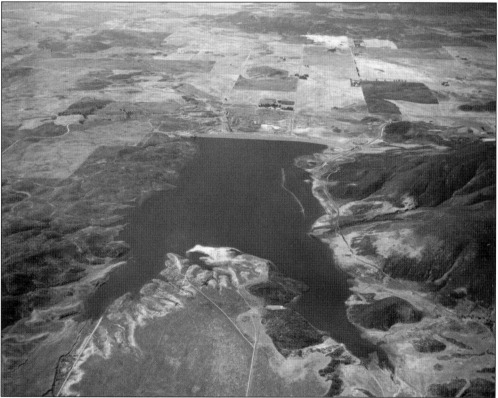

LAKE SKINNER AND SURROUNDINGS. This aerial photograph is from a point above the east end of Lake Skinner. The clump of trees in the center is the Marius Nicolas ranch, with the Alamos Schoolhouse hill behind it. The brush-covered area a mile to the right of the hill on Pourroy and Thompson Roads is the Pete Pourroy ranch. The airport isn't there yet, nor are the houses that are seen now.

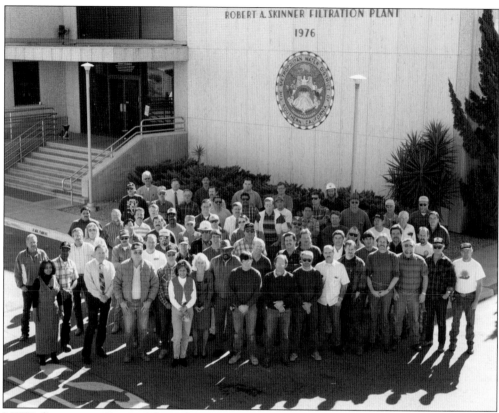

MWD Filtration Plant. The Robert A. Skinner Treatment Plant was completed in 1976. In 1985, the company took this picture of all the employees that worked at the plant. Since then, the capacity has been more than doubled. Lake Skinner was slated to become Auld in the minds of the locals but was named for Skinner because he was general manager of the water district from 1962 to 1967.

Lake Skinner Recreation area. This picturesque view up Middle Creek toward the Rawson Ranch near the oak grove in the center background is vivid in the memory of Bill McBurney, who herded his father's sheep on alfalfa where the lake is now. The sheep were prone to bloat on the lush alfalfa, so he had to drive them up the hill in the middle after a half-hour on the alfalfa.

HYATT'S FIRST TEACHER. Clara Robertson was born to Mark and Lena Robertson of Sage. She became a teacher and taught at Rawson School as well as Helvetia in Domenigoni Valley before being hired for the Auld District's Hyatt School in 1899 as the first teacher. (Walt Cooper.)

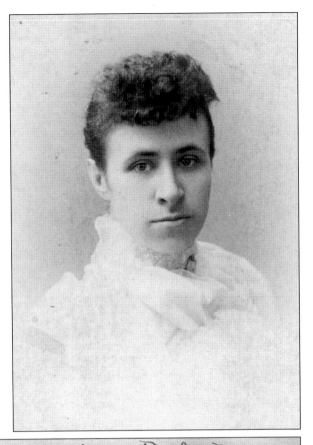

Miss Robertson,
April 27 1901,
May Heaven on you its choicest blessings shower. Is the sincere wish of your pupil
Irene M. Buck.

A TRIBUTE. Clara Robertson, later Mrs. Fred Cooper, was a favorite teacher of all the children. She took them on nature walks, teaching them about the plants, animals, and rocks they encountered. In 1901, her students presented her with an autograph book with a sentiment such as this from each of her 15 students. The amazing thing is that they were all written with a steel ink pen without blots. (Joan Cooper Roripaugh.)

PEARL DICKINSON. Hattie Pearl Dickenson (right), the seventh teacher at Hyatt School, is shown with an unidentified student. She boarded with the Arthur Buck family, and they made her feel at home. In pioneer society, teachers were revered and treated as honored guests by the host family and were respected by everyone. The trustees of Hyatt who hired her were A. E. Buck, W. D. Baisley, and Dr. L. L. Roripaugh. (Carl and Betty Rheingans.)

ADJUSTING. In 1910, Dickinson was a meek 25-year-old with nerves of steel who traveled 3,000 miles from her home in New Hampshire to become a teacher at Hyatt School and work with children like these. She adjusted quite rapidly to the change in climate as well as Western manners. She emphasized teaching refined manners and enriched the students with entertaining stories of the east coast. (Carl and Betty Rheingans.)

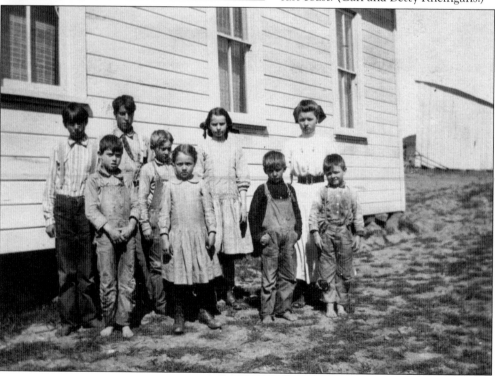

ELIZABETH CONRAD. Upon completing college, Betty searched vainly for a job in the city but finally accepted an offer from Lulu Sheld, a trustee for Hyatt School in 1937. As they drove through the farms in Menifee and French valleys, she was greatly impressed by "the miles of amber waves of grain with few houses." She was a natural at multi-tasking, as she taught eight grades in one room.

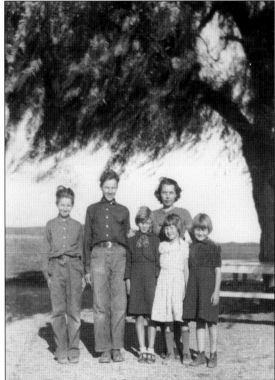

OPERATING HYATT SCHOOL. Once Elizabeth Conrad was visited by her supervisor from Riverside, who observed her style of interacting with students. She was so friendly and helpful to each kid in turn that he remarked, "you aren't teaching—you are playing house." Elizabeth Conrad inspired the older boys to arrive early to start a fire in the wood stove so she could make soup or cocoa.

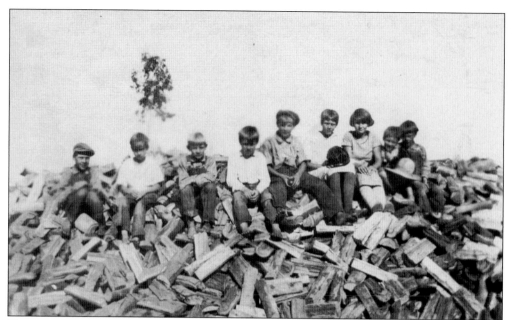

KEEPING WARM. Hyatt students pose on top of 1926's firewood pile, which was donated by the trustees. It must be autumn, because the pile is so large and the children are barefoot with leathery, dirty feet. There was only one wood stove for heat, and no electricity or gas, so students read from the light of the windows. (Ellen Sheld Milholland.)

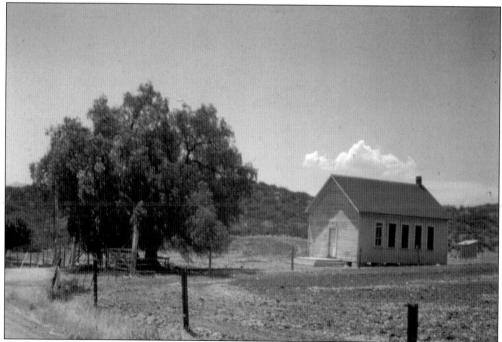

HYATT SCHOOL. This picture of Hyatt School was taken by Nawton Bashaw on a beautiful day in 1959. The school had been closed for over 20 years. Tommy and Lewie Rawson had bought the property and took care of it. The school still stands along with the pepper tree, which looks the same today as 70 years ago; a lunch table was built around the trunk for shade. (Bashaw family.)

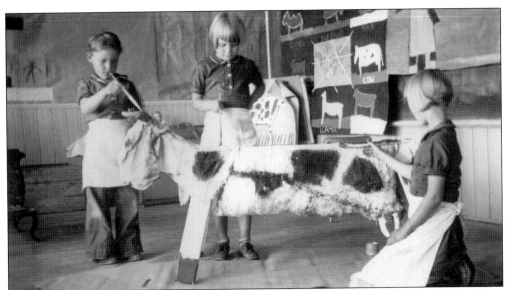

THE MILK COW. Buddy Embry (left) and Alice (center) and Viola Carlson put the final touches on the "star" of the show. Buddy explained how they used a sawhorse for the body, a board for the head, real cow horns, made skin out of gunnysacks stuffed with paper, and braided rags for the tail and udder. The play taught about milk from feed to table. (Viola Carlson.)

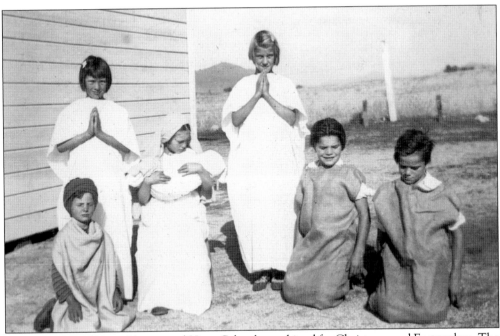

THE CHRISTMAS PLAY. Alamos and Hyatt Schools combined for Christmas and Easter plays. The 1938 Christmas play used, from left to right, Hyatt kids Glen "Herk" Carlson, Virginia Shield, Alice Carlson, Viola Carlson, William McBurney, and Homer McBurney as angels, Mother Mary, and shepherds. Alamos had the stage, so it was used by both schools. (Elizabeth Conrad Sheld.)

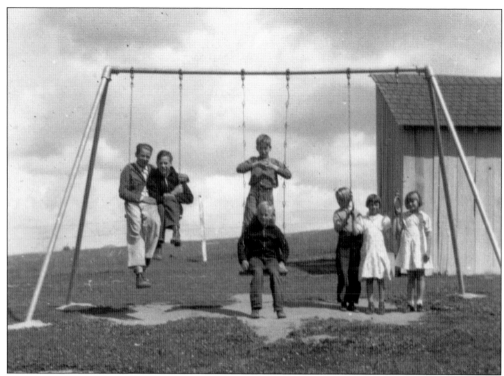

THE SWING SET. The swing set and bars were the main piece of recreational equipment. Sherm Sheld and Betty Conrad are in the left swing; Clarence Hodge and Glen "Herk" Carlson are next; and Virginia Sheld, Alice Carlson, and Viola Carlson are on the rings. The outhouse in the background had both boys' and girls' doors but was not partitioned below.

PLAY DAY. Play day was greatly anticipated by the students of the rural schools. A host school, like Winchester, would provide the space and equipment for the various sports competitions, such as dashes, long jumps, a three-legged race, a slow bicycle race, and so forth. Ribbons were awarded to every participant.

Five

THE TUCALOTA

The Tucalota refers to hills, a creek, and a valley in southwest Riverside County. It is also spelled *Tecolote* by some—Spanish for "owl" or for the sound an owl makes. Old-timers pronounce it Tuck-a-lo-tee. The Tucalota Creek's headwaters form in the Red Mountain area (4,610 feet). The creek meanders through Weber Valley, crossing Route 3–Sage Road near where East Benton Road and the community of Sage merge. Traveling southwest, the creek winds near East Benton Road though Tucalota Valley into Auld Valley and Lake Skinner. It leaves Lake Skinner (spillway 1,479 feet) heading southwest through Borel Ranch and merges with the Santa Gertrudis Creek near Winchester and Nicolas Roads. This waterway runs above and below ground. The Borels had dikes along the Tucalota on their property by 1910 to irrigate alfalfa. Heavy seasonal rain will bring a wall of water tumbling downward causing floods, and yet, during drought times, the creek bed is as dry as dust.

Floods that cause destruction also provide soil with needed nutrients and moisture for abundant crops. The money from a bumper crop would be used to purchase new equipment. A 1905 edition of the *Hemet News* under Sage notes states "Good crops help the merchant as well as the farmer." For many years, the creek ran with swimming holes forming along the way, but during the drought years of the 1950s, many dried up. The flood in 1980 caused severe damage, and hundreds of thousands of cubic yards of soil washed into Lake Skinner. Lake Skinner acting as a flood control downstream has allowed for the creation of riparian forests along the Tucalota.

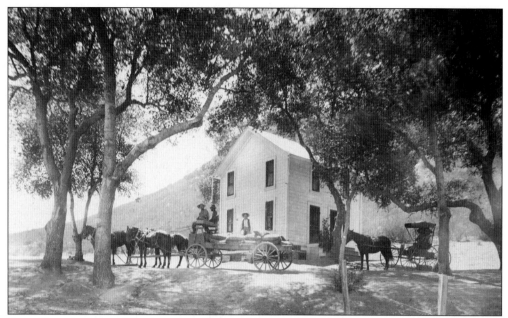

FRED COOPER HOUSE. This two-story house sold in 1905 and became known as the Milholland Place. Though never seeing another coat of paint, it stood proudly as a landmark until it burned in the 1970s. Stin and Eliza Milholland Sheld lived there for almost 30 years, making it a place of activity both agriculturally and socially. Other Milholland families lived there throughout the years. (Joan Cooper Roripaugh.)

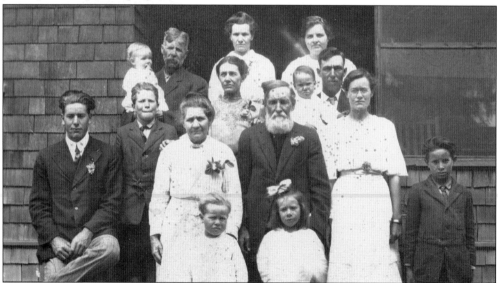

THOMAS MILHOLLAND FAMILY. The Thomas Milholland family moved to Winchester by train in 1889 from Nebraska. The youngest children attended Hyatt School while at the two-story house, and when the traveling preacher could not make it, Thomas Milholland filled in. He was a professional photographer and lived in Valle Vista for many years. Pictured from left to right are (first row) Bill, Bessie "Toots," and Joe Rice; (second row) Bert, Cora and Thomas Milholland, and Bertha Morris; (third row) Chauncey Rice, Annie Baisley, Cora and Albert Morris; (fourth row) Dean, Wilford and Ellen Rice, and Bessie Wilson.

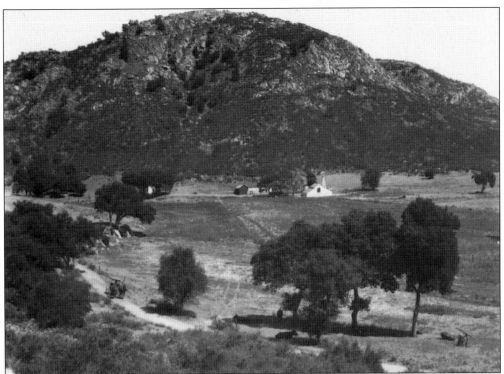

MILHOLLAND RANCH. Nestled in the Tucalota Valley up against a large rocky hill, the ranch prospered under the capable hands of Stin and Eliza Sheld. Subirrigated alfalfa grew thick, and cattle grazed on pasturelands, with grain and hay grown in season. A large swampy area grew until the flood of 1980. The children—Jenny, Jessie, Fanny, Huck, Calvin, Helen, Ted, Maudie, and Thomas—lived in this idyllic setting. (Viola Carlson.)

STIN SHELD. Stin Sheld's father and his family left Sweden in 1888. Stin left an orphanage and began working on a ranch at age 15. In 1904, he became the foreman on the Fuller Rancho near Corona. Later he became foreman of the Pioneer Ranch. His brothers, Iner and Dan, worked there also. In 1907, he married Eliza Milholland and settled in the Tucalota Valley. (Viola Carlson.)

91

SAILORS ON LEAVE. Alongside the two-story house, the family celebrates the Fourth of July. Bert Milholland (third from left) was a gallant soldier in World War I and is pictured with a friend in navy outfits on leave in the 1920s. Jenny and Jessie Sheld were the first nieces born to Bert, who loved to play the fiddle and banjo. Bert graduated from Hemet High School in 1913. (Viola Carlson.)

AW. Doris Jean Milholland stands on a stump and sniffs a rose. In the background, the lush Tucalota meadow with wildflowers makes a fine portrait. The photographer, Elizabeth Conrad (later Betty Sheld), lived with Richard and Ellen Milholland while teaching at the Hyatt School.

THE OLD SWIMMING HOLE. The Tucalota Creek still flows a bit, but back in the olden days, it was a stream where natural pools formed, and before flooding, farmers made earthen dams to store water. In this natural swimming hole, a fellow is floating all by himself. Many youngsters learned to swim and dive from the rocks. It is said Huck Sheld could dive from the highest rock into the shallowest water.

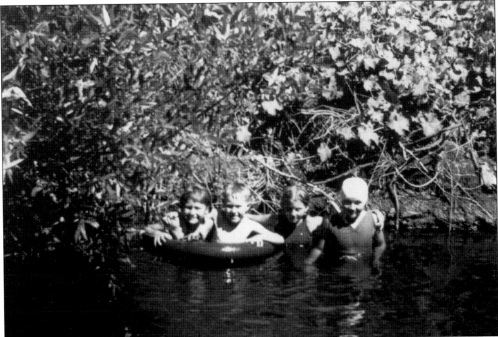

ANOTHER SWIMMING HOLE. Swimming in the Tucalota with wild grapes all around made summertime fun. Inner tubes from automobile tires made fine floaters for Alice Carlson (left) and cousin Buster Sheld (second from left). Maudie Sheld (third from left) and Viola Carlson (right) were lifelong friends. C. O. and Fanny Sheld Carlson built a cabin between the two-story house and the Tucalota Creek in 1935. Living so close to the water made swimming a frequent event in their young lives. (Viola Carlson.)

WILDFIRES. Occasionally wildfires broke out in the hill county, causing flames, whipped by wind, to race through canyons. Very little could be done to contain them, unlike today with air tankers and helicopters. Before electricity, fire danger was high due to the use of candles, kerosene lamps, and woodstoves. Many homes and schoolhouses burned.

FOOD FOR THE FAMILY. Hunting through the Tucalota and up into the hills brought needed provisions. Young boys would handle rifles with respect, even taking them to school in order to shoot a couple of rabbits for supper on the way home. Chauncey Rice became a renowned marksman and was highly decorated during World War II. There were two places one didn't hunt: the Vail Ranch and the Rawson Ranch.

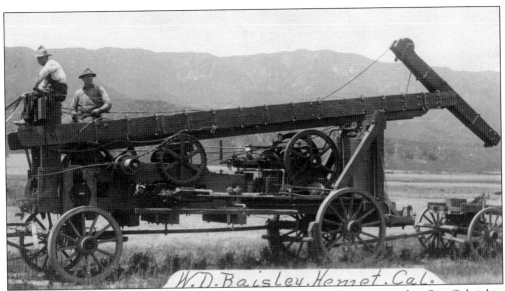

W.D.Baisley.Hemet.Cal.

BAISLEY DRILLING RIG. Well drillers George Herbert Baisley and sons arrived in San Gabriel in 1874. The oldest son, Denton, homesteaded 160 acres along Baisley Creek in Bautista Canyon around 1888. He created a wind-powered machine using windmill blades that could pull a plow or mower. His father, George, bought 40 acres from Fred Cooper called the Pear Orchard in the Tucalota Valley. On June 27, 1894, Denton married Annie Belle Milholland.

FRIENDS FOR LIFE. Dent Baisley (right) is pictured with "old side-kick" Bragg McDaniel. In 1935, Denton's bib overalls caught in the well-drilling machine. His legs were crushed and had to be removed. Years later, Dent went to Hemet to visit Bragg on his deathbed. With tears in his eyes, he said he'd come for the quart of whiskey they'd bet on whoever died first. Bragg recovered and didn't have to pay.

THE PEAR ORCHARD. Britomart "Bertie" Baisley (right), Denton's sister, was married to Luther Menifee Wilson, the miner after whom Menifee Valley is named; he died in 1899. They had three children. James Menifee "Mike" Wilson, the oldest, married Bessie Milholland. Bertie then married Lincoln Pierce (left) and moved around 1910 to her dad's place, the Pear Orchard in the Tucalota Valley. One of their children, Mildred "Peggy" Pierce, married Hugh Trunnell.

BERTIE PIERCE WITH CHILDREN. During the Depression in the 1930s, Peggy and Hugh Trunnell moved to the Pear Orchard. Much to their surprise, a family had moved in without permission and was burning the barn one board at a time to keep warm. It was a job to make the place livable. Their children, Don and Marge, have fond memories of living there and going to the Hyatt School. Here with Bertie Pierce are her children, George and Mildred. (Don and Esther Trunnell.)

BIRTHING HOSPITAL. In 1923, Bessie Milholland Wilson equipped her home on Inez Street in Hemet as a maternity hospital. Mike Wilson had a gunsmith shop out back where he spent his time. Bessie had received her nursing certificate and midwife training, making her very capable. She closed in 1943, when the Hemet Hospital was opened. "Aunt" Bessie (left) and her sister-in-law Peggy Trunnell (right) worked together for many years. (Don and Esther Trunnell.)

SUCCESSFUL HUNT. Hugh Trunnell holds two bobcats; marauding wild animals brought danger to stock and small children. Animals were also trapped and skinned for their hides. During the Depression, people did whatever they could to make money to supplement their home gardens and farm-raised animals. Hugh and Peggy's son, Don, married Esther Bergman from the pioneer family of Aguanga. He farmed and drilled water wells, and Esther taught at Cottonwood School. (Don and Esther Trunnell.)

EXTRACTING HONEY. An unidentified man holds the bee box frames that honey bees fill with wax combs and honey. Ira Church, married to Jenny Sheld, had an apiary business. George Milholland was also in the bee business. He enjoyed working with the bees and had great skill and knowledge. The Rawson family was famous for its honey. Sadly the backyard business has ended.

COOLING. George Milholland (center) is pictured under a shade tree along with his wife, Nellie Morris Milholland, her brother Jessie (second from left), and grandson Jeff Milholland at their home in Tucalota Valley. George and Nellie married in 1909 and bought the Starr-Cooper place, where they built an adobe house, in 1925. Nellie, one of the younger children of Leonidas and Nancy Burris Morris, was born in Wildomar in 1891 and lived to be 100 years old.

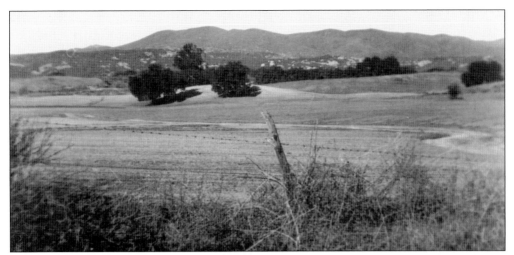

GEORGE MILHOLLAND RANCH. George Milholland's place was north of East Benton Road. The hill blocks the view of their house and was graded flat in the 1960s, becoming a beautiful horse ranch. George and Nellie enjoyed company, and everyone loved the dance floor in their living room made of salvaged bowling alley lanes. Their children—Tommy, Richard, Oren, Winnie, Georgia, and Charlotte—went to the San Ignacio School.

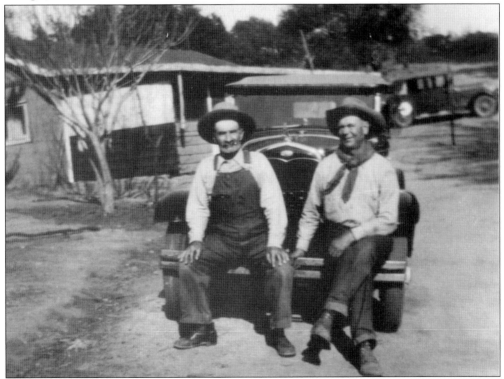

FATHERS-IN-LAW. George Milholland (left) and Dan Sheld, pictured at the George Milholland Place, were related by the marriage of their children Richard and Ellen. As youngsters, they left school to work, and as young men, they both drove teams of horses down the steep mountainside from Idyllwild to Valle Vista with wagons of cut and uncut timber. They both farmed for a living and were proud of their families.

CABIN. The Carlson cabin, built in 1935, stood until a fire around 2005. It represents the small homes built during the first part of the 20th century. With a load of lumber and local assistance, the structure could be built in a few days. Many such homes were built in the area under the Homestead Act, but sadly most families had to move on in a few years. (Viola Carlson.)

DESCENDANTS. Joan and Noble Roripaugh represent the blending of old-time families. Joan's mother, Jessie Sheld, was raised in the two-story house. Joan's father, Walt Cooper, never spent a night in that house, which his father Fred Cooper built. Noble Roripaugh comes from one of the first families to settle in Auld. His great uncle, L. L. Roripaugh, owned land and was the local doctor who delivered many babies of the area. (Joan Cooper Roripaugh.)

Six

SAGE

Long before the pioneer settlers, at the beginning of the Spanish Mission era, the padres sometimes used a route similar to Sage Road to travel from Temecula to San Jacinto. Mid-route there was an Indian rancheria built along the Tucalota Creek, and it was probably the mission fathers from San Luis Rey who named it San Ignacio. This handy campsite provided water, shade, and a pleasant place to rest.

Years later, as American settlers began moving into the area, Andrew Bladen began mining the hills around San Ignacio in 1873. There was enough success to cause him to build the Bladen Mining District. The ore contained silver with a touch of gold, and when others began mining, a mill was built. Bladen continued mining but also farmed and was a blacksmith. Another settler in the area, Charles Ticknor, opened a store along the main road. By the 1870s, there was enough traffic for the San Diego Board of Supervisors to declare it a public road, but instead of using Bladen's name as its reference, they used Ticknor's Store. They also appointed Steven St. John as road overseer.

By the 1880s, families began coming into the area to farm. Beekeeping became a popular business because of the thousands of acres covered in sage and plants like it. The San Ignacio School District was formed, and a one-room school was built around 1880. In 1891, the small community petitioned for a post office, and in August of that year, Sage was picked as the official name. Some speculate the name Bladen was not chosen because it didn't have an attractive ring. Sage may have been chosen because they wanted their name to bring thoughts of the surrounding natural environment.

Steve Lech says in his book *Along the Old Roads*, written in 2004, "Unlike most other areas of the county, this particular area was not subject to any specific town site development prior to the county's formation. As such, it remained a sparsely populated but important part of the overall story of the development of Riverside County."

THE RICHFIELD SIGN, DOWNTOWN SAGE. The center of Sage is known for the plant with the same name and oak trees, seen here looking south. From 1946 until 2002, the California Department of Forestry had a fire station behind the Richfield sign. It moved north on Sage Road. Over generations, Sage has been a crossroads and gathering spot. Many have appreciated the quiet coolness in summer because of its higher elevation and ocean breeze. (Lorna Jean Pittam Bien.)

THE OAK TREE IN THE MIDDLE OF THE ROAD. Looking north toward Hemet, 13 miles away, the store is on the right. Charles Ticknor began the first store in 1879. A few adobe blocks still remain. The famous oak tree in the middle of the road is standing for the photograph; unfortunately, it was cut down in the 1960s. The locals fought valiantly, however, for the grand oak's right to life in the middle of State Road 79. (Lorna Jean Pittam Bien.)

OLD-FASHIONED GAS PUMP. This original gas pump needed someone to pump the gas up into the glass top before it could drain into the car's fuel tank. For many years, Choppy Rice was the station attendant and light mechanic who handled the task. East Benton Road can be seen heading through the backcountry towards Auld Valley. Ethel Pittam, with her fine hairdo, looks like a bouquet among the irises. (Lorna Jean Pittam Bien.)

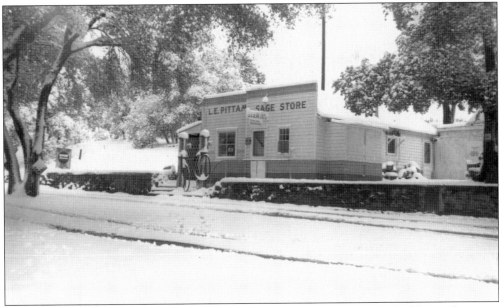

PITTAM STORE. The Pittam Store, with the living quarters in back, looks like a Christmas advertisement with several inches of snow that fell in January 1949. Lew Pittam purchased the store in 1934 from Musetta Hunsaker. Lew and his wife, Ethel, maintained the store for 30 years. It was a favored stop for the youngsters getting off the school bus on their way home from an hour's ride from Hemet. (Lorna Jean Pittam Bien.)

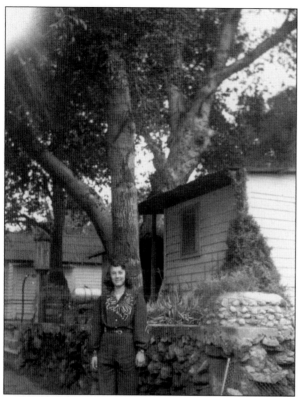

LORNA JEAN. Lorna Jean Pittam lived far from town and from other children. She got her driver's license at 14. She remembers a birthday party Lester Reed put on for his granddaughter visiting from the city. Lorna Jean was picked up with lots of other children for miles around to attend this special occasion. She had a great time, though she did not know the granddaughter and never saw her again. (Lorna Jean Pittam Bien.)

CONCRETE DANCE FLOOR. Sage has had a concrete slab for years, providing an ideal spot for dances, and with the picnic tables around, the dances often included a potluck. Family gatherings and anniversaries made good use of the simple facility. When the California Department of Forestry station was a stone's throw away, the Roadrunner Auxiliary provided a favorite fund-raising pancake breakfast on Memorial Day. They continue to have them at the new station. (Lorna Jean Pittam Bien.)

FLOOD CONTROL DITCH. The beautifully designed ditch with local rocks, cans, bottles, and fill dirt was built by Lew Pittam and Leo Willis. The community wanted the rain water to stop running down the side of the road during storms, so they devised a plan and worked as a team and created the drainage needed to keep the road safe and provide a unique ditch in the process. (Lorna Jean Pittam Bien.)

STONE ARCH. Lorna Jean's grandmother, Mrs. M. F. Bragg, was not afraid to walk across this fine bridge. The experts told the local people that their bridge could not hold up due to the lack of arch in their design. The locals said "Oh" and went on about their business. It is still holding more than half a century later. The Pittam family provided the park-like setting across the street from their store. (Lorna Jean Pittam Bien.)

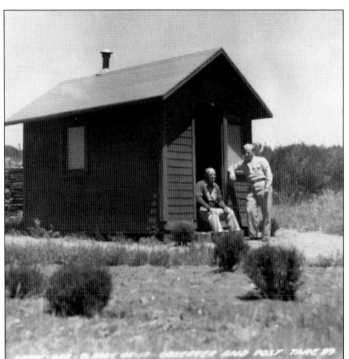

AIRCRAFT EARLY WARNING STATION. World War II had caring people, young and old, who protected our shores from enemy attack. This air observation station was built specifically for that purpose. Every community had something much like it. Volunteers checked in and spent four hours looking through binoculars at the sky for any unaccountable light or listening for sound. They had logs to fill out and a special direct phone line to report suspicious activity. (Lorna Jean Pittam Bien.)

RECLAIMED RUBBER. World War II knitted communities together, enabling those at home to do their part. People collected old tires for rubber among other valuable things to be recycled to make defense products. Along with collecting, everyday items were rationed, and people learned to do with less or without for the sake of the fighting forces overseas. Everyone wanted the Allied forces to be strong. (Lorna Jean Pittam Bien.)

NEW SAGE FIRE STATION. The first fire station in Sage consisted of a gray tent with wood siding halfway up the walls and was manned by a young ranger, John Sanchez. He spent the summers of 1946 and 1947 there before a station was built by the California Division of Forestry at the crossroads of East Benton and Sage Roads. In 2002, it was replaced by a new station. Capt. John Sanchez retired after 35 years. (Jerry Milholland.)

ROADRUNNERS. In 1972, the ladies of Sage decided to form an auxiliary to support the volunteer fire department. This picture shows the first meeting, in which the women were elected to their positions. From left to right are president Doris Smith, vice president Dorothy Morgan, treasurer Naomi Kohn, and secretary Shirley Green. They named themselves the "Roadrunners" and still work together, providing items for craft fairs and putting on a pancake breakfast every Memorial Day. The money earned goes towards fire equipment. (Doris Milholland Smith.)

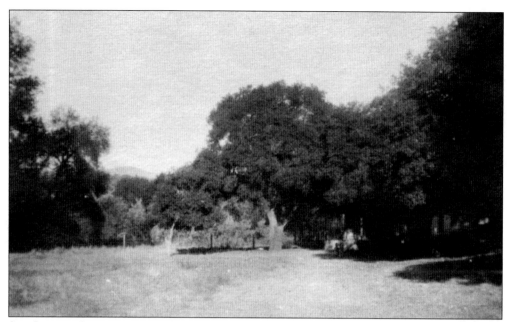

SAN IGNACIO SCHOOLHOUSE, 1920. Vivian Pollard took this shot of her beloved school, but the angle she chose only shows the giant oaks that surrounded the building, keeping it cool in the spring and fall. The road to the school was just a pair of wheel tracks through the pasture or range. The school, built before 1880, was on East Benton Road until it burned to the ground in 1932. (Vivian Pollard.)

VIVIAN EOLA POLLARD. San Ignacio was Vivian Pollard's first school in California, and she seemed to be an adventuresome lady for the time. She loved to take trips in her Model T as far as Pala Mission and Temecula, which were real trips on the dirt roads. She boarded at the Earl and Alice Brubaker home. The school had 13 students in 1920. (Vivian Pollard.)

FIELD TRIP. Vivian Pollard taught at the San Ignacio School in the 1920–1921 school year. Pictured among the rocks are her students on a field trip. "This is rugged country" are words aptly placed under this photograph. Pollard allowed the children to explore freely, trusting their judgment. She was free with the use of her Ford Model T to go on field trips into the country. (Vivian Pollard.)

BESSIE DINSMORE AND VIVIAN POLLARD. Bessie (left) and Vivian are pictured among the great boulders that are easy to find around Sage. As one of the older students, Bessie was mentored as a friend instead of the usual teacher-student relationship and is seen in several of Vivian Pollard's photographs. (Vivian Pollard.)

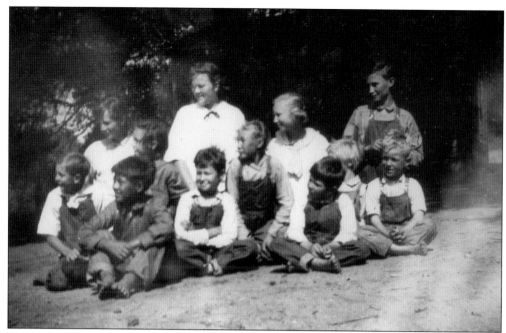

SAN IGNACIO STUDENTS, 1920. Pictured are (first row) Albert Flores, Tommy and Richard Milholland, and Dan Hunsaker; (second row) Charles Scott, Marion Haslam, and Opal and Hershel Higgins; (third row) John Scott, Bessie Dinsmore, Nellie Hunsaker, and Lennard Haslam. They are watching Archie Hunsaker, who didn't get in the picture. The Hunsaker children's father owned the Sage store until 1934. (Vivian Pollard.)

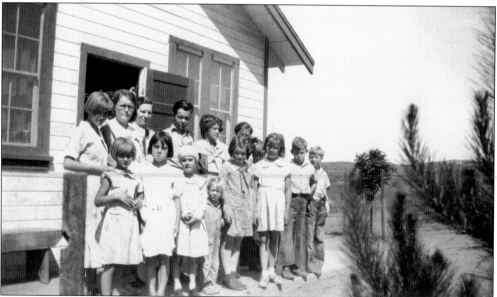

NEW SAN IGNACIO SCHOOL. After the first school burned down in 1932, a new school was constructed on San Ignacio Road about a mile south of East Benton Road. The student body includes Lorna Jean Pittam (first row, white hat), Alfred Morris (behind Pittam), and Verna Parks (left of Morris), among others. The school closed for good in 1955 for lack of enough students, causing the students to be bussed to Hemet Elementary School, 16 miles away.

Seven

RAWSON COUNTRY

James Rawson was one of the earliest settlers in Greater French Valley. His wife, Maria Zuniga de Verdugo, was from one of the social elite families during the Spanish and Mexican eras in the pueblo of Los Angeles. Her father was a descendant of the Count of Monterey, who served as the viceroy of Mexico. She was related to the Estudillos, who owned the Rancho San Jacinto. Traveling in those circles, she learned much about living on the frontier that stood her in good stead when she married James. She was responsible for gathering wild bees into her hives and starting a thriving honey business.

After marrying in 1870, they moved to the Glenoaks area near Glenoaks Road and DePortola Road. There was a dispute over boundaries with the Pauba Rancho, which was still operating under a Spanish land grant. In 1879, the Rawson family moved on to Crown Valley which became known to all as Rawson Country. It was the area bound by Diamond Valley Lake on the north, French Valley on the west, the Magee Hills on the east and Tucalota on the south. At first it was just 120 homesteaded acres but expanded as they purchased land from the Southern Pacific Railroad, the Bell and Corrales families, and others. The beekeeping business expanded when Maria Rawson partnered with Philander Bell, who introduced removable-frame bee boxes. The partnership endured until 1893, when the Rawsons bought Bell out and Bell retired.

James Rawson started a grain-farming operation in the 1880s, when the railroad allowed access to markets. He did custom harvesting as well as harvesting his own grain with his steam-powered equipment while most farmers were still using horsepower.

Tommy Rawson was a colorful individual who always wore a distinctive wardrobe consisting of puttees, tan military-type clothes, a necktie, and a ranger-style hat. The Brahma cattle that he introduced were known everywhere in California.

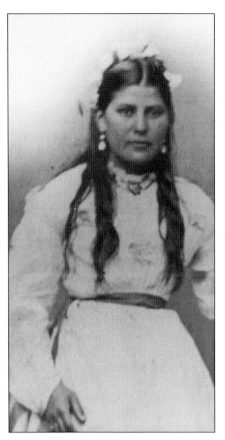

MARIA ZUNIGA DE VERDUGO, 1870. Maria Zuniga de Verdugo (later Maria Rawson) was the daughter of Maria Verdugo and Refugio Zuniga. Maria was born in Los Angeles and related to and acquainted with many of the early Spanish California families. Maria Zuniga de Verdugo and James Rawson were married in San Gabriel on November 17, 1870, and settled in Mud Springs, later called Glenoak Valley. They farmed and raised cattle in Glenoak Valley and the neighboring Tucalota Valley.

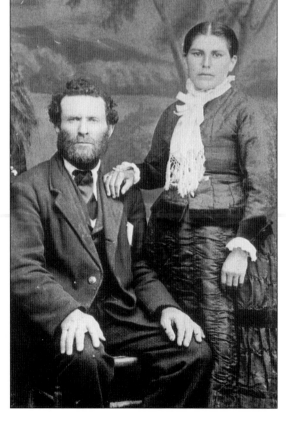

JAMES AND MARIA RAWSON. James Rawson was born in New York State to Thomas and Elizabeth Rawson. The family made several moves, settling in Iowa. At about 15 years of age, he headed west, traveling with a Mormon caravan to Salt Lake City, working for the Pony Express, and finally settling in El Monte, where he rented land from Maria Verdugo.

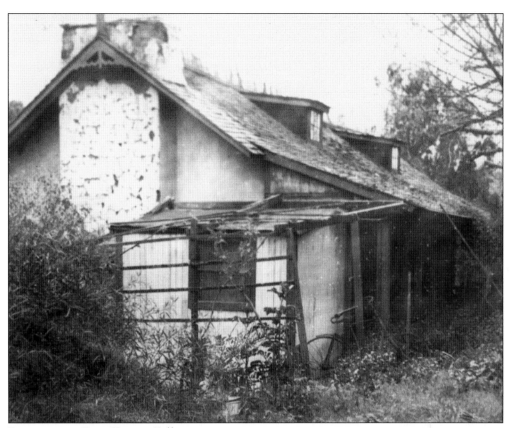

RAMONA AND JUAN DIEGO. Following a dispute over the northern boundary of the Pauba Rancho in the late 1870s, the Rawson family moved to the Crown Valley area, where they settled at the site later known as the Rawson Ranch. It was located in the large canyon now called Rawson Canyon south of Crown Valley, so named because the perimeter of the valley is surrounded by hills resembling the points of a crown. Juan Diego, later known as Alessandro in Helen Hunt Jackson's novel, *Ramona*, and Sam Temple, known as Jim Farrar in the same novel, helped with the family relocation and the construction of the adobe home. Later additions to the home were of wood frame construction.

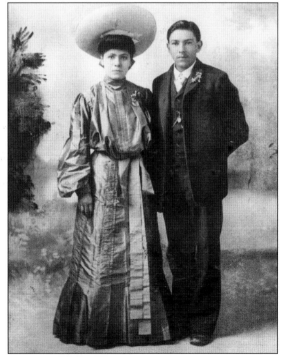

TOMMY RAWSON. Settling in the Crown Valley area in 1879, the family consisted of James and Maria, daughter Mary, and sons John, James, and Thomas. Left behind at the Glenoak Valley were the graves of their infant son, Juan, and the infant child of Juan Diego and his wife, Ramona. William, Lewis, and Frank (who died in infancy) were born after the move to Crown Valley.

FOURTH AND FIRST SCHOOLHOUSES. In 1879, James Rawson established the Rawson School. There were four schools that served the community from 1879 until 1916 under the direction of James and then Tommy Rawson. Dances were held at the schoolhouses to raise money to help defer the costs of the school. The third schoolhouse burned in 1910, and after improvements were made, school was held back at the first schoolhouse. The fourth schoolhouse was constructed in 1914 and closed in 1916, bringing the era of the Rawson School District to an end.

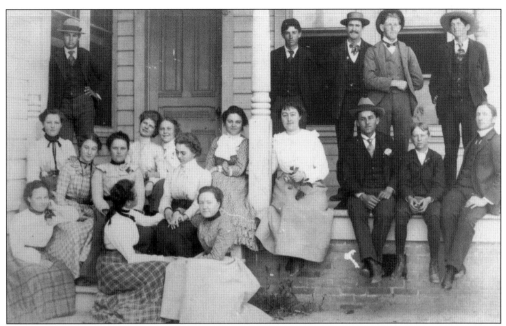

1901 Hemet High School Students. In his early years, Tommy Rawson (seated, wearing hat) attended school on the Rawson Ranch. He completed his education at Hemet High School. He rode his bicycle from the ranch to Hemet morning and night—a 20-mile round-trip.

1902 Commencement Program from Hemet High School. Traveling to and from school by horse or bicycle, Tommy was one of the two graduates of the class of 1902. He was a determined scholar.

ó2.

COMMENCEMENT EXERCISES

OF THE

HEMET UNION

HIGH SCHOOL

June 13, 1902.

CERTIFICATE OF APPOINTMENT.

CLERK OF SCHOOL DISTRICT.

Riverside, Cal., July 29, 1913.

n accordance with the power vested in me by Section
9 of the Political Code, I hereby appoint you,
~my Rawson, *Clerk of Rawson*
ol District in the County of Riverside
State of California, to hold office until the first day of
next succeeding, and you are by virtue of this appoint-
t fully authorized and empowered to discharge all the
es of said office.

Raymond Cree

County Superintendent of Schools.

EDWARD HYATT

SUPERINTENDENT
OF
PUBLIC INSTRUCTION

Mr. Hyatt asks your kindly help this year for re-election.

His name will be on every ballot, regardless of party designations, since the law has made the office non-partisan.

His work has been approved by the great majority of those having opportunity to know —eight out of every ten. Test this for yourself.

CERTIFICATE OF APPOINTMENT. Tommy Rawson's interest in education was a lifelong one. He was a trustee and the clerk of the Rawson School District and worked diligently to maintain the attendance required to keep the school open.

EDWARD HYATT CAMPAIGN CARD. Tommy Rawson maintained a long and warm relationship with Edward Hyatt, an outstanding educator who became principal at San Jacinto, went on to become the Riverside County superintendent, and was finally the California state superintendent of public instruction. The Rawsons remained friends with the Hyatts and supplied them with honey when the Hyatt family moved to Sacramento. A 1918 letter from Margaret Hyatt thanked them for the "simply splendid honey" and included cards to be disseminated locally to secure votes for Edward in the upcoming election.

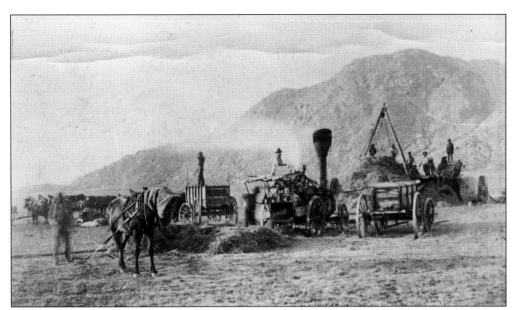

RAWSON STATIONARY THRESHING OUTFIT, 1898. James Rawson died in 1899, leaving the operation of the ranch to Maria and Tommy. Maria, crippled since 1893, remained active in the ranch operation until her death in 1923. Tommy devoted his life to the operation, management, and expansion of the ranch. He continued many of the ranching practices established by his parents. The custom grain-threshing business was started by James Rawson and thrived at a time when tracts of land were being cleared in the vicinity of the ranch and farming operations were being established. The arrival of the railroad provided the necessary access to markets for the fruits of the land.

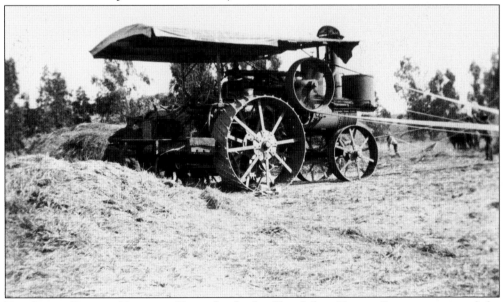

THE STRAW BURNER TRACTOR. Upon the death of his father, Tommy Rawson continued the custom threshing business in the San Jacinto, Menifee, Temecula, and neighboring valleys. The use of larger and more modern equipment necessitated some general improvements on the ranch, which included the building of a huge barn to house the horses and mules that powered the more modern combine harvesters.

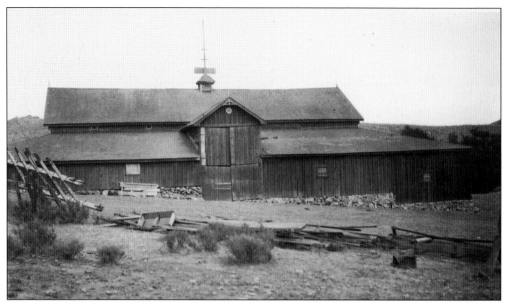

BARN. The new barn was constructed under the direction of a noted Japanese architect named Tanaka, made available to Tommy Rawson by his friend Frank Miller while Tanaka was working on an addition to Frank Miller's Mission Inn. The Japanese influence can be seen in the new barn constructed in 1901–1902.

PIGS. Survival on the rugged ranch lands required a creative approach and a variety of income sources. Beyond dry farming and beekeeping, Tommy Rawson had a herd of sheep and kept pigs in the area along Rawson Creek. Shown here is Tommy Rawson's grandson Gary Wanczuk. This photograph was taken in 1949.

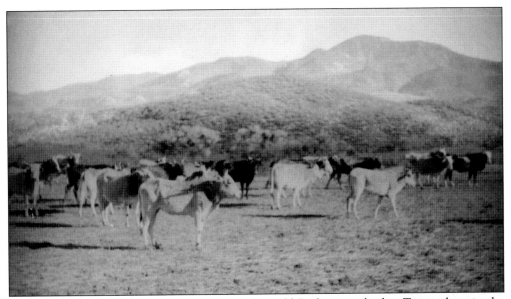

BRAHMA CATTLE. Folks who happened upon the wild Brahma cattle that Tommy kept in the Tucalota area were sure to give a wide berth to the very imposing animals. He found the Brahmas the best adapted to the rugged terrain and sparse forage. Tommy imported the cattle from India, believing that they were especially adapted for the chaparral hill country.

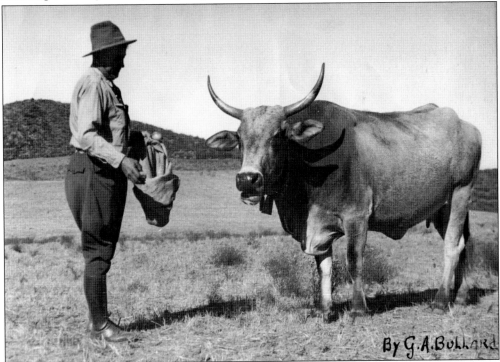

By G.A.Bullard

BRAHMA BULL. This prize bull was the heart of the cattle business and the herd Tommy Rawson kept in Tucalota Valley at the east end of present Lake Skinner. In 1965, Bob White, Finest White's son, rounded up the whole herd with other cowboys and drove it to the M. A. Nicolas ranch for further transport to a buyer.

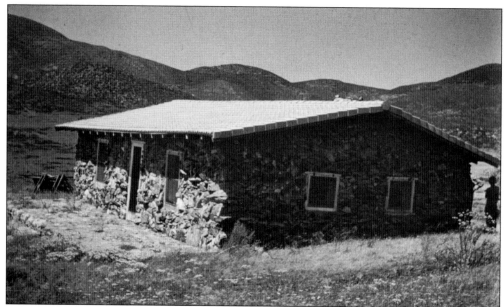

ROCK HOUSE, 1949. During World War II, Tommy had an arrangement with the military to utilize the ranch for training troops. In 1939, four men from March Field, attracted to the area, purchased a piece of property and built a house from the rock found locally. Tommy maintained communication with one of the four men, J. E. Stewart, and hosted Gen. Hap Arnold on hunting trips on the ranch. The rock house, having seen much better days, still stands.

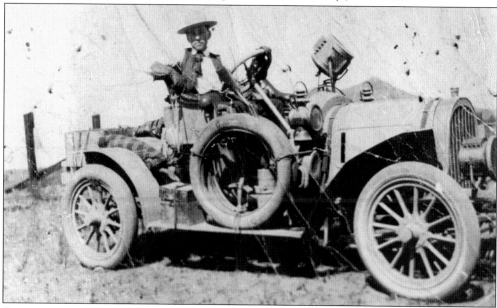

CROSSING THE DESERT. Beyond his interest in the ranch, Tommy Rawson (above) was ever an adventurer. He had a profound interest in the history of the Southwest and sought out the Lost Ship of the Desert, the Lost Peg Leg Mine, and other mines and lost treasures. In 1907, he and a friend crossed the desert to Yuma before the existence of the plank road. The trip took two weeks and an automobile equipped with leather tire coverings and four 20-foot-long mattress-like cushions that were placed ahead of the front tires to prevent the car from sinking into the sand.

(Elect the Man - Not the Party)

Your Vote and Influence Will Be Appreciated.
A Booster for the Whole County and State. An Oil Road to Every Farm House. Advocates full co-operation with the Federal Government in all Relief Projects.

The Construction of a Highway connecting the Hemet and San Jacinto Valley with Borego Valley by the way of Anza; Reducing the distance between Yuma and Los Angeles 67 Miles.

Advocates Reduction of Taxes 20%.

Primary Election - August 30th, 1938
TOMMY RAWSON
For Supervisor 5th District

CAMPAIGN LITERATURE. Tommy also had an insatiable interest in current events and politics. He ran for Riverside County supervisor for the 5th District in the primary election of 1938. While the issues of the day were of critical importance to him, he could not take time from the operations of his beloved ranch to actually mount a campaign.

CALIFORNIA STABLES
LIVERY AND BOARDING
373 NORTH MAIN STREET

HACK STAND
AT STABLES

LOS ANGELES, CAL., *Oct. 22* 19*18*

Dear Friend Tom and Mr. Rawson,—

You folks aught to be awfully glad you are away from the "plague." The "Spanish Flu" is raising the devil in our City. Nearly all her funds are down. I Jack I phoned (you remember Jack) that he was getting over it but now his wife was down and the lad

BUTTON LETTERHEAD. Tommy Rawson was a charismatic individual who always had a story that told of fascinating people, places, and events. In truth, he did cross paths with people who achieved fame, including the likes of Gen. George Patton, the labor leader John L. Lewis, and the 1920 Olympic champion runner Charles W. Paddock. His stories were also of encounters with individuals who had achieved notoriety for less than reputable reasons. Tommy enjoyed time spent with local ranchers. He maintained a relationship with Jess and Lola Button, who erected the concrete home that stands today in Lake Skinner Park next to the Alamos School. The Buttons lived in Los Angeles, where they had a livery and Jess was a mortician. During World War II, they saw their Auld Valley home as a potential refuge from the perils that they feared may await them in Los Angeles.

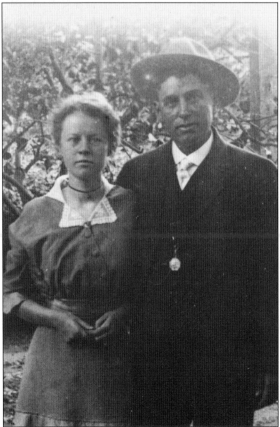

BUTTON HOME. The Buttons took special care in building the house because of the potential for fire and earthquake. The Button home, constructed in the early 1900s, stands as a monument to the thought and care they put into the planning of the home they built on the knoll.

MARRIAGE PICTURE. While it is safe to say that Tommy Rawson's first love was his ranch, he did have other loves. In 1913, Vera Florcken, whose 1912 diploma from State Normal School at Los Angeles was signed by the California state superintendent of public instruction Edward Hyatt, was hired to teach at the Rawson School. A romance developed. On October 3, 1915, Vera and Tommy were married in Los Angeles.

VERA AND TOMMY. The two returned to live at the ranch. On August 20, 1916, pregnant with their child, Vera left the ranch to give birth to their baby in a hospital in Los Angeles. This picture was taken on the day of departure.

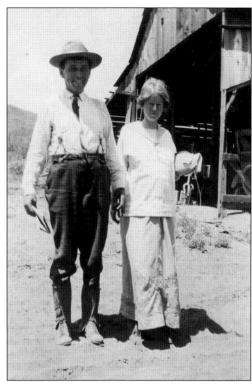

VERA, BABY ANNA, AND TOMMY. In April 1917, Vera returned to the ranch with baby Anna Laurie. The family did not remain together for very long. By October, Vera was back in Los Angeles with Anna Laurie. While the devotion of Tommy and Vera to one another seemed to last through their lives, circumstances surrounding them prevented them from staying together. Tommy remained devoted to his beautiful daughter. Many saw the sign at his Edenic refuge at Tucalota that named it "Annie Laurie's Park."

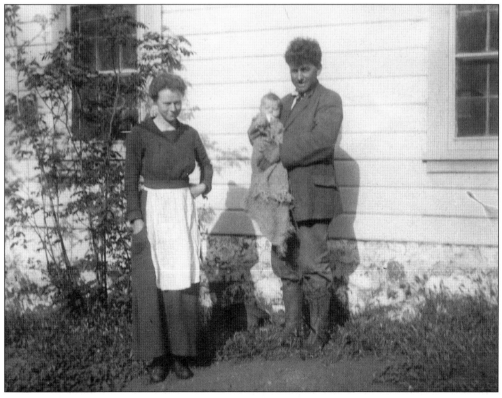

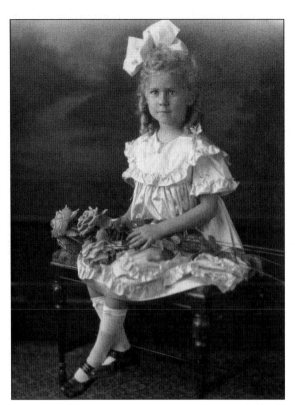

Tommy's Girl. Tommy saw his daughter too infrequently for all, but as her mother remarked, Anna Laurie had the same dimple in her chin as Tommy. When Anna Laurie won a beauty contest as a child, Tommy saw to it that it was reported in the *Hemet News*.

Gary and Glen. What Tommy missed out on as a father he made up for as a grandfather. In 1948, Tommy's two grandsons, Gary (left) and Glen Wanczuk (right), began spending their summers at the ranch learning the ranching and life lessons that Tommy relished imparting.

QUEEN BEE. Tommy nicknamed Gail, the youngest grandchild, "Queen Bee" and treated her in a manner consistent with the name he gave her. While Tommy's first love was the ranch, he stressed to his grandsons the importance of education. Gary and Glen provided critically needed help to Tommy, who essentially ran the ranch on his own. Gary was the bee man and Glen was more comfortable tending the sheep. The summer of 1957 was the last summer Gary spent on the ranch with his grandfather.

TOMMY AND FIDO. Tommy remained dedicated to his ranch until the wee hours of the morning of November 16, 1957, when, by the dim light of his kerosene lamp, the flame of his life was extinguished. In his lifetime, he had seen many things. He had held most of the ranch through the very difficult years following World War I and then through the Depression years of the 1920s and 1930s. He expanded the ranch to about 15,000 acres. He embodied the spirit of the California pioneers who succeeded even when faced with seeming insurmountable adversity.

CALLING CARD. Upon the death of Tommy and the subsequent death of his brother, Lewis, much of the Rawson Ranch was sold. Some of the ranch lies within the Southwestern Riverside County Multi-Species Reserve. This has preserved the character of a portion of the original ranch. As evidenced by his calling card, Tommy considered himself a conservationist. It is fitting that the land should remain relatively unchanged as a reserve for the plants and animals he loved.

RAWSON BRAND. This is not the end of the story of the Rawson Ranch. Tommy's grandson Gary shared Tommy's devotion to the ranch. Gary dedicated his life outside of work to exploring the local history, to maintaining the remaining land held by the family, and to purchasing what he could of the old ranch. He continued a beekeeping operation, planted a small orchard of Arkansas black apples like those in the original family orchard, and registered the Rawson Ranch brand.

CABIN. Upon retirement, Gary fulfilled his dream of moving back to the ranch, where he lived in a small structure that was once used as a honey house. While his life was cut short, like his grandfather he instilled in others the passion he held for the ranch. The family treasures the ranch and the history it embodies. While most of the remaining ranch is held by Gail Wanczuk Barton, Tommy Rawson's granddaughter, there are two younger generations that appreciate the beauty, the history, and the wonder of the Rawson Ranch.

THANKSGIVING. Gail and her family frequent the ranch and plan to make it home. Thanksgiving is always celebrated under the majestic oaks, where stories are told of times past and a sense of the presence in spirit of those who went before is maintained. The family looks forward to many generations enjoying the land and continuing the legends and traditions of the Rawson Ranch. For Thanksgiving 2007, Anna Laurie, the beautiful lady on the right (91 years young), is standing by her father Tommy's carriage. From left to right are David Barton and Gail Wanczuk Barton; their children, Michael and Lea; Anna Laurie's great-granddaughter Sarah; Mike's wife, Amy; and Amy's daughter Bethany.

ACROSS AMERICA, PEOPLE ARE DISCOVERING SOMETHING WONDERFUL. *THEIR HERITAGE.*

Arcadia Publishing is the leading local history publisher in the United States. With more than 5,000 titles in print and hundreds of new titles released every year, Arcadia has extensive specialized experience chronicling the history of communities and celebrating America's hidden stories, bringing to life the people, places, and events from the past. To discover the history of other communities across the nation, please visit:

www.arcadiapublishing.com

Customized search tools allow you to find regional history books about the town where you grew up, the cities where your friends and family live, the town where your parents met, or even that retirement spot you've been dreaming about.